THE PASTELS BOOK

COLORWORKS 4

DALE RUSSELL

A QUARTO BOOK

Copyright © 1990 Quarto Publishing plc
First published in the U.S.A. by North Light Books, an imprint
of F & W Publications, Inc.
1507 Dana Avenue
Cincinnati, Ohio 45207

ISBN 0-89134-340-7

All rights reserved. No part of this book may be reproduced in any form or by any means without permission from the Publisher.

This book contains examples of graphic design work.

These examples are included for the purposes of criticism and review.

This book was designed and produced by Quarto Publishing plc The Old Brewery 6 Blundell Street London N79BH

SENIOR EDITOR Sally MacEachern
EDITORS Paula Borthwick, Eleanor van Zandt
DESIGNERS Penny Dawes, David Kemp, Julia King, Karin Skånberg, Hazel Edington
PICTURE MANAGER Joanna Wiese
PICTURE RESEARCH ADMINISTRATION Prue Reilly, Elizabeth Roberts,
PHOTOGRAPHERS Martin Norris, Phil Starling

ART DIRECTOR Moira Clinch
EDITORIAL DIRECTOR Carolyn King

Manufactured in Hong Kong by Regent Publishing Services Ltd Typeset by Ampersand Typesetting Ltd, Bournemouth Printed in Hong Kong by C & C Joint Printing Co. (H.K.) Ltd

DEDICATION

With great love, I would like to thank my husband Steve for patiently guiding me through the days and nights overtaken by color and my daughter Lucy Scarlett for remaining happy while color came first.

The color tints printed in this book have been checked and are, to the publisher's knowledge, correct. The publisher can take no responsibility for errors that might have occurred.

CONTENTS

Using Colorworks

6

Introduction

12

Optical Illusion, Proportion and Texture

14

Psychology

16

Marketing

18

Culture and Period

20

THE COLORS

22

The 25 main colors with specifications

22

The main colors on background tints

24

Applications

34, 44, 54, 68, 82, 104, 114, 124, 142

Credits

144

Using Colorworks

To make the most of the *Colorworks* series it is worthwhile spending some time reading this and the next few pages. *Colorworks* is designed to stimulate a creative use of color. The books do not dictate how color should be applied, but offer advice on how it may be used effectively, giving examples to help generate new ideas. It is essential to remember that *Colorworks* uses the four-color process and that none of the colors or effects use the special brand name ink systems.

The reference system consists of five books that show 125 colors, with 400 type possibilities, 1,000 half-tone options, and 1,500 combinations of color. But even this vast selection should act only as a springboard; the permutations within the books are endless. Use the books as a starting point and experiment!

When choosing colors for graphic design it is almost impossible to predict the finished printed effect. In order to save valuable time spent researching, you can use the series' extensive range of colors to provide references for the shade with which you are working.

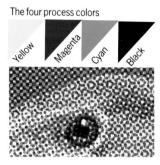

▲ Enlarged detail showing how four process colors overlap to produce "realistic" color.

The books are ideal for showing to clients who are not used to working with color, so that they may see possible results. They will also be particularly useful when working with a specific color, perhaps dictated by a client's company logo, to see how this will combine with other colors. Equally, when working with several colors dictated by circumstances – and perhaps with combinations one is not happy using – you will find that the constant color charts, colorways and applications will show a variety of interesting solutions. The numerous examples in *Colorworks* can act as a catalyst. enabling you to break out of a mental block – a common problem for designers who may feel that they are using a wide variety of colors but actually be working with a small, tight palette.

Finally, when faced with a direct color choice, you should use Colorworks in the same way you would use any other art aid – to help create the final image. The books are designed to administer a shot of adrenaline to the design process. They should be treated as a tool and used as a source of both information and inspiration.

TERMINOLOGY USED IN COLORWORKS

Main color: one of the 25 colors featured in each book.

Colorway: The main color plus two other color combinations.

Constant color: The main color with 56 constant colors.

Y: vellow

M: magenta

C: cyan

Blk: black

H/T: half-tone

F/T: flat-tone

TECHNICAL INFORMATION

When using Colorworks, or any color specification book, remember that paper stock, lamination and type of ink can change the effect of chosen colors. Coated papers, especially high quality, tend to brighten colors as the ink rests on the surface and the chalk adds extra luminosity, while colors on uncoated paper are absorbed and made duller. Lamination has the effect of making the color darker and richer.

Colorworks specification

Color bar: GRETAG

Screen: 150 L/IN.

Film spec.: AGFA 511P

Tolerance level: +2% - 2%

Col. density: C = 1.6 - 1.7

M = 1.4 - 1.5

Y = 1.3 - 1.4

Blk = 1.7 - 1.8

Ink: Proas

Paper: 135gsm matt coated art

Plate spec.: Polychrome

Dot gain: 10%

Printed on: Heidelberg Speedmaster 102v

Printing sequence: Black/Cyan/Magenta/Yellow

On the next four pages you can see, in step-by-step form, exactly how to understand and use the color reference system shown in *Colorworks* and how you can incorporate the ideas into your designs.

It is essential to remember that *Colorworks* uses the four-color process – none of the effects uses the special brand-name ink systems – usually described as "second colors."

1. GRADATED COLOR

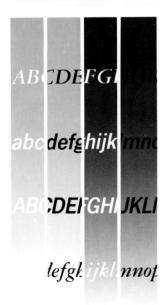

The color scale shows the main color fading from full strength to white. If you are using a gradated background, the scale clearly demonstrates at what point reversed-out type would become illegible — with a dark color you may be able to reverse out down to 20% strength, with a pastel only down to 80%, or perhaps not at all, in which case the type should be produced in a dark color.

The opposite would be true if the design incorporated dark type on a fading dark color. Again, unless a very subtle result is required, the scale indicates at what point type would become illegible.

The other use of the fade gives the designer more color options – perhaps you like the color on page 102, but wish it was slightly paler. With the gradated shading you can visualize just how much paler it could be.

2. TYPE OPTIONS

The main color with different type options; solid with white reversed out; type printing in the color; black and the type reversed out as color; solid with black type. These examples demonstrate the problems of size and tonal values of the type.

The type block is made up of two typefaces, a serif and sans serif, both set in two different sizes.

Ossidet sterio binignuis gignuntisin st nuand. Flourida

trutent artsquati, quiateire semi uitantque tueri; sol etiam

8½pt Univers 55 —7pt Univers 55

Size

Using the four-color process the designer obviously has no problems choosing any combination of tints when using large type, but how small can a specific color type be before it starts to break up or registration becomes a problem? The type block shows when the chosen tints work successfully and more important when they do not.

Ossidet sterio binignuis tultia, dolorat isogult it

9pt New Baskerville: 30% Mag demonstrates no problems.

gignuntisin stinuand. Flourida prat gereafiunt quaecumque

7pt New Baskerville 40%Y 30%M 20%C the serifs start to disappear.

Tonal values

Obviously, when dealing with middle ranges of color, printing the type black or reversed out presents no legibility problems. But the critical decisions are where the chosen colors and shade of type are close. Will black type read on dark green? Will white type reverse out of pale pink? When marking up color, it is always easier to play safe, but using the information in *Colorworks* you will be able to take more risks.

Ossidet sterio binignuis tultia, dolorat isogult it

The problem is shown clearly above: using a pastel color (top) it would be inadvisable to reverse type out; with a middle shade (center) the designer can either reverse out or print in a dark color; while using a dark color (bottom), printing type in black would be illegible (or very subtle).

3. HALF-TONE OPTIONS

This section demonstrates some possibilities of adding color to black and white half-tones where the normal. "realistic" four-color reproduction is not desired or when the originals are black and white prints. This section gives the designer 800 options using various percentages and combinations of the process colors.

The mood of the picture can be changed dramatically from hard edged photographs enhanced by a touch of

color to pale pastel tints suitable for backgrounds or decorative devices.

Each of the four options are shown using the main color at full strength and at 50% strength. When specifying them to your color separator make sure they understand what you are asking and clearly mark the percentage tint of each color that you want. Also, emphasize whether it is a percentage of half-tone or a flat tint that is required.

4. COLORWAYS

This page shows the main color with other colors. It acts as a guide to help the designer choose effective color for typography and imagery. Each color is shown as four colorways; each colorway shows the main color with two others.

The three colors in each colorway (corner) are in almost equal proportions. The effect would change dramatically if one color was only a rule or small area. Use the colorways to find the appropriate range for your design and adapt it accordingly.

For information on using the central square and its use in commissioning photography or illustration see page 10.

The choice of color has not been limited to the safe options. The easy neutrals cream, white, and gray have been used, but so have more unusual combinations.

The colors chosen show various effects; look at each corner, if necessary isolating areas.

Colors are shown projecting forward, sometimes using the laws of optics which say that darker, cooler shades recede.

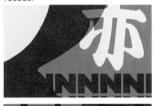

A Sometimes, due to the proportions, defying them.

There are classic color combinations.

Colours that are similar in shade

abcdefghi

Lise these colors for background patterns, illustrations or typographic designs where the color emphasis has to be equal.

These colors are not advisable if your design needs to highlight a message.

Analyze your design to see how dominant the typography, illustrations, and embellishments need to be versus the background, then use the colorways to pick the appropriate colors or shades.

100% main color

100% black H/T plus full strength of the main color

100% black H/T plus 50% of the main color

50% strength of main color

50% black H/T plus full strength of the main color

50% black H/T plus 50% of the main color

color at full strength

100% black H/T plus a flat tint of the main 100% black H/T plus a *flat* tint of the main color at half strength

H/T using only the main color at full strength

The photographs (left) have been marked up for origination using options from Colorworks. It is unusual to ask for a percentage half-tone - make sure you mark it clearly.

COLORWORKS ► THE PASTELS BOOK

When selecting colors, it is very important to eliminate any other color elements that might affect your choice. As has been demonstrated in the color optics section (p14), the character of a color can be dramatically changed by other, adjacent colors.

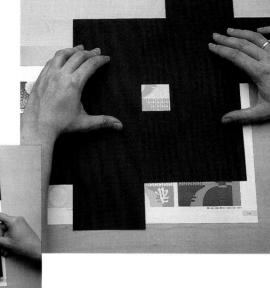

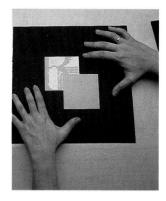

■ The colorways have been designed in such a way that you can mask out the other color options — isolating the area you want to work with or even small sections of each design.

▼ The colorways can also be used if you are selecting the color of typography to match/enhance a photograph or illustration; again masking out the other colorways will help. A print of the photograph or illustration can be positioned in the central area, and the mask moved around.

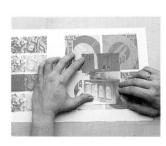

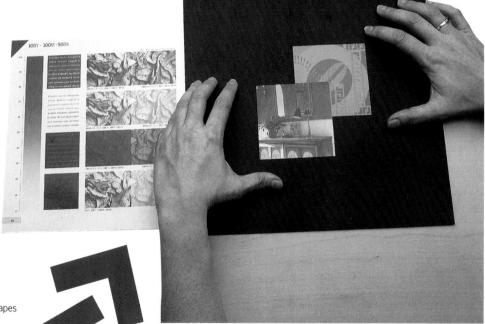

The design shown on this page was created to demonstrate the practical use of *Colorworks*. It combines many half-tone effects and color combinations.

The options illustrated are drawn from *The Pastels Book*. For more suggestions and further inspiration, refer to the other books in the series.

➤ Using elements from *The Pastels Book* pages 96-97, 98-99.

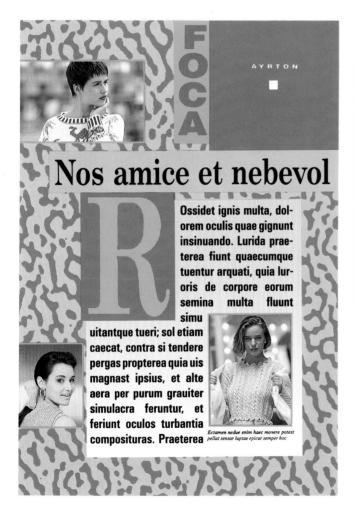

■ Using elements from *The Pastels Book* pages 40-41, 42-43.

Pastels introduction

"A pale delicate colour."

Collins English Dictionary; Publishers William Collins Sons and Co. Ltd., London and Glasgow; Second Edition 1986

"Pale and light in color."

Webster's Ninth New Collegiate Dictionary, Merriam-Webster Inc., Publishers, Springfield, Massachusetts, U.S.A. 1983

- Color is not tangible; it is as fluid as a musical note. Although it may be described, the verbal or written words often bear no relation to its actual form. Color has to be seen in context, for a single shade used in conjunction with another color can take on a whole new character. Searching for a particular shade can be very confusing somewhat like humming a tune and searching for a forgotten note.
- No matter how much theory exists, it is the eye of the designer or artist that is responsible for using color creatively. The fact that color can be rationalized and then break its own rules with complete irrationality is what makes it so fascinating.
- This book is about process color. By the very nature of the process system, colors are not blended, as with pigments, but shades are selected visually. Unlike pigment colors, process colors can be mixed without losing any of their chromas. The process primary colors are magenta, yellow, and cyan, with black to create density and contrast, allowing dot saturation to establish values of lightness and darkness. The pigment primaries are red, blue and yellow.
- The concept of process color is not really new. The German poet and scientist Goethe (1749-1832) looked at effects of light and darkness on pigment color in a way that strongly relates to modern interpretation of process color. In complete contrast, a practical approach was taken by the 20th-century German painter Hickethiev, who created a precise notation system based on cyan, magenta, and yellow for printing. Between these two extremes lies the concept of the process color system.
- The colors used in these books had to be systematically chosen to prevent *Colorworks* from dating or the colors from being a purely personal choice. It was important to rely on theory and I finally selected over a thousand colors for the five books that make up this series. This meant working with literally thousands of colors, and yet in spite of this comprehensive palette, there would still be a precise shade that would remain elusive.
- My next major task was to select each image from advertising agencies, design consultancies, illustrators, and actually "off the walls." Every piece of printed matter, label, shopping bag or magazine was a potential gold mine of material for the books. Many images had to be excluded,

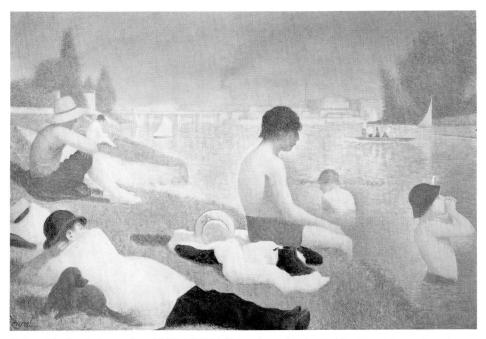

Bathers at Asnières by Georges Seurat (1859-1891) Pointillism, using a color wheel to determine precise complementary shades, evokes the heat of a summer day.

even though they had superb coloration, because they did not tell a story with one predominant color.

Colorworks examples had to have immediate impact, with one color telling the story – whether in harmony with others, through shock tactics, providing a backdrop, creating a period setting, making instant impact for the recognition of the image content, or simply combining superb color use with design.

Color combinations are infinite, and every day wonderful examples of color and design are being created. Having drawn from just some of these, I hope the *Colorworks* series will be a reference to inspire, confirm, and enjoy.

Optical illusion, proportion and texture

Pastel colors are literally tints of solid color; they are a lower percentage of the one-hundred percent shade. In *Colorworks*, pastel colors have been determined at a color saturation of below fifty percent. We therefore, in many cases, follow the theories and practices of the primaries magenta, cyan, and yellow discussed in the other books of the *Colorworks* series. For instance, in *The Blue Book*, there is mention of shades of blue having immediate connotations with sky and water. These associations can still be applied to the pastel shades of blue shown in this book. But a shade such as lilac has a specific set of associations.

Pastels can make objects appear larger in size and yet lighter in weight. They blend with light to create a clean, unobtrusive atmosphere. By their very nature, pastels are perfect as a background color, allowing the more saturated tints to perform in the foreground. However, they can also be used effectively when applied to a foreground, highlighting imagery and typography.

By applying the slightest of pastel tints the glare of a white page can be subtly broken, creating an impression of texture without dominating. Pastel tints can also be used behind typography or graphics to highlight specific statements or facts. Several tones of either the same or differing pastels can create movement on a graph or graphics.

In a complex and delicate design the illusion of a shadow cast over part of the page is created through tints. This is extremely sparingly applied, and yet it is not lost among the intricate detail, which has a highly textured, almost threedimensional quality. The colors chosen blend softly together, giving the impression of mottled lilacgray, which in turn makes the white warm rather than harsh. The addition of cobalt gives further dimension and added warmth to the background.

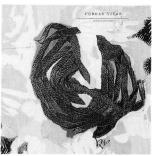

A Texture and the illusion of texture are created by the use of color and collage. The harmonious tones of peach and white form a textural background through light and shade intensities for the dominant ocher red application of braid. The braid appears to bleed a soft tint of terra cotta onto the background. The addition of another color scheme behind "RIO" seems incongruous but strengthens the textured harmony of the entire page, while highlighting the name.

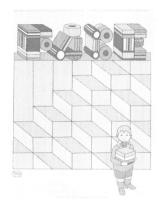

An Escher-like approach gives a sophisticated touch to what could have been a very saccharine design. Variations of two key colors make a complex design appear simple, with illusions of depth and height.

The red ocher of the abstract design is used again in the chart, but this time it assumes a dominant role. The soft pastel tint of this shade provides harmony. A soft gray tones with the third shade of red ocher.

dops and Management Hierbadays an war Clerkinst products on the war Clerkinst and products on the status of position in their robots (bids. They are consulted configure on the control of the control of

ture of Lectures, Work-

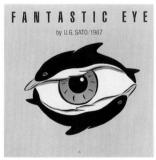

A The soft pink background makes it possible to see two images at once. The strong, predominantly black and white illustration of two dolphins swimming around a ball is immediately recognizable. At the same time, the natural association of the pink with human skin tones enables us to see an eye. The soft harmony of the blue and green sphere relates to the pastel pink, while the black typography and the eye/dolphins project from it.

The use of pastels, applied to the page in broad strokes of color to create defined areas, is both effective and artistically pleasing. The choice of blue as a background to the text, while primrose and peach sorbet highlight the images, makes the page eyecatching and easy to read. At the same time, it creates a sense of space and depth that takes the page into a further dimension.

▲ Deep, moody shades, combined with abstract design, create dramatic impact. The atmosphere relies upon the textured application of line and color, as well as the contemporary palette.

▲ The palest of peach backgrounds floats the imagery, while "shelves" created by chrome yellow give stability to the design. The colors have the feel of middle-tone nursery shades but, in fact, include much stronger hues.

Psychology

Pastels can be bright and childlike or subtle and romantic. They can suggest cleanliness and purity or lightness and simplicity; or they can be cloyingly sweet. The word "pastel" tends to evoke a stereotyped image of female domesticity, but, in fact, most pastels including pale green and fawn are natural colors that appeal to both sexes.

Pastels imply the gentle aspects of nature. They are traditionally associated with newborn babies and fluffy yellow chicks. The colors are also reflected in the regeneration of the spring countryside with the pinks of blossom and primroses among the new growing grass.

There is also, however, a sickly side to pastels.

The sight of sugar pink can still bring back memories of cotton candy and roller coasters – of children's birthday parties and their aftermath.

In general, pastels are harmonious, restful and relaxing; they are easy on the eyes and allow the subject to filter through gently.

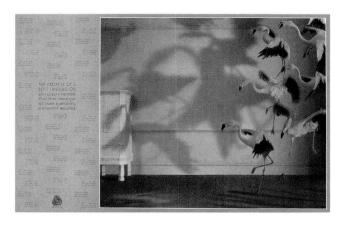

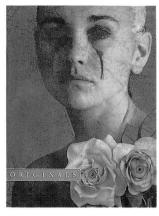

A The blue tint relates to sadness and depression. It also has associations with Picasso's "blue period" in this image. The strong psychological message of unhappiness is then given further implications of unease, and a sense of the macabre, by the apparant reversal of color. The surreal tear (or is it blood?) takes the eye to the gentle pink of the roses. It is then that we become aware of the pale blue eyes staring from the centers.

This advertisement incorporates the psychological associations between color and imagery. The "soft landing" is created in burnt sienna against the pastel pink of the warm and gentle image. We are reassured that the delicate legs of the birds can safely land. The salmon tint to the flamingoes' feathers, with their accent of black, forms a sympathetic link between the baby pink and the sienna carpet.

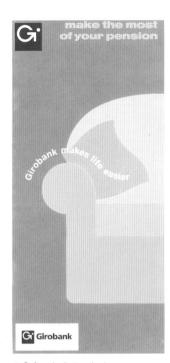

▲ Soft and relaxing shades create an atmosphere of comfort and security. The message also has great clarity, due to the contrast of cheerful apricot against the harmonious shades of lilac. These colors, with their complementary clarity, tend to appeal to the elderly. However, the approach to the design and color is contemporary and not condescending.

Marketing has used the psychological reactions associated with color as the main theme for this packaging. The use of a deep pastel tint to recreate the atmosphere associated with melting heat, arid desert, and different degrees of light against land and water is highly effective.

The literal use of color is employed to great effect. The strength of the waterfall is increased by tint. The pure white cover gives the blue, greater impact. The blue panel and logo confirm the power of water.

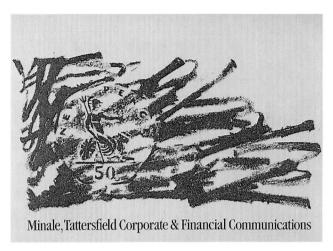

A The psychological association between money and the pink of The Financial Times in the mind of the British reader has given a creative opportunity to the designer of this financial document. The textured effect of rubbing wax crayon on paper over a coin playfully echoes the company's own logo. The witty application of this design to the pink of the newspaper makes an ideal cover for the company's own financial report.

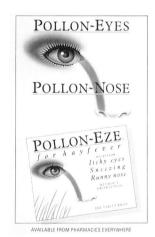

▲ The misery of hay fever is immediately conveyed by the color and graphics. The subtlety of the small percentage of geranium tint in the eye gives way to a more intense shade of geranium in the nostril. The soft graphite around the lids gives impact and strengthens the pink tint of the irritation, while the gentle strokes of grass green reveal the allergy source.

Marketing

The term "pastels" actually covers a very wide palette, ranging from pale sugar almond pink to sophisticated grayed yellows and beiges. Pastels can be bright and candy-colored as well as soft and romantic.

Displays, packaging, and signs using soft pastel shades tend to lose impact in strong light and are therefore not suitable for sunny climates. The same hue, a few shades darker, may prove an effective alternative.

Pastels can be used for a wide range of products. The sugar shades of pastels are the obvious choice for confectionery; turquoise can be clinical; light green and blue are equally suitable for the extremes of the business world and that of children's clothes and products. The family of beiges and fawns may create a feeling of warmth and softness, yet used in isolation can convey a bleak neutrality. Pink and peach are feminine colors which are commonly used for cosmetics.

Food packaging often uses pastels: they have a fresh, clean appearance which is less aggressive than rich colors and friendlier than stark white.

In addition to these traditional associations, there is a growing use of more obscure color mixing of pastels by contemporary designers. An original approach can be achieved by using the less common secondary pastels, such as pale olive and muted orange; by combining tangent hues such as lilac and primrose; or simply by applying a pastel that is discordant with the saturated tone.

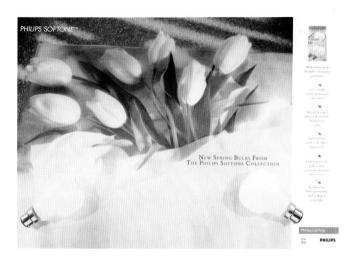

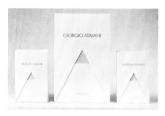

M The elegance of the subtle hint of pastel yellow enhances the minimalist sophistication of the packaging, which recreates the initial letter of the designer's name. A secondary harmonious shade appears within the central triangle of the letter, revealing the product contained within the package.

▲ The subtlest of pastel tints are overlaid onto a pure white background. The color is so minimal that the effect is almost that of a hand-tinted monochrome image. The gentleness of the color is the subject of the caption, and the title of the product, "Softone Collection". This concept is reinforced by the delicate pastel tones around the bulbs. Marketing uses the association between spring flower bulbs and the pastelcolored lightbulbs to create a memorable image.

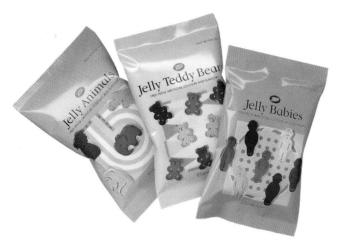

▲ The complexity and intricacy of the pastel tints against indigo linear graphics catches the eye while promoting the many possible applications associated with the paper. The quality of the printing and texture in conjunction with the 3-D aspect of the image tell the story. The text becomes secondary — essential when an advertisement is often just glanced at by readers.

A Pastel shades are associated with candies and children. The choice of tonal shades for the packaging conveys the idea of a series, and yet allows individual identity for the varied contents. These packets are designed to appeal not only to children but also to parents, for their color palette implies purity and freshness. The pastels project the stronger colors of the jelly candies. while providing appealing backgrounds.

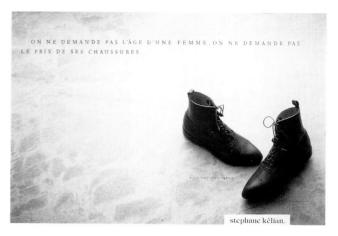

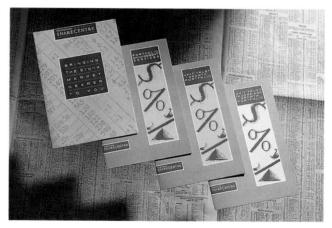

▲ Elegance, quality of craftmanship, and the use of natural materials are conveyed in this sophisticated and understated advertisement. The textural lilac-gray marble background complements the polished, rich tan of the leather. The pastel shade evokes the atmosphere of a piazza and the world of haute couture.

▲ Pastels have been used to create a new approach to designing brochures that relate to the stock market. By linking these shades to the background pink of the British newspaper, *The Financial Times*, the color palette is explained. The juxtaposition of these soft shades with a sober mole gray gives them authority and stability; the repetition of this palette in a series of brochures provides continuity.

Culture and period

Although found in nature, within the written history of organic color pastels are comparatively "new" colors; they are attenuated forms of the saturated shades. In Britain, the Regency period (early 1800s) favored light green; earlier, Georgians were particularly fond of the strongest of pastels, such as buttercup yellow and bright pink. The Victorians used an extensive range of colors, though favoring tints of violet, such as lilac, and mauve.

The 1920s and, more specifically, the Thirties featured pastels in both printing and fashion. Color combinations such as orchid and eau de nil were extremely popular, as was the juxtaposition of strong deep colors and pastels – burgandy and fawn, for example.

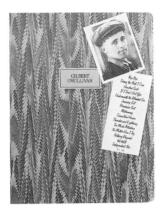

A Here is an "album" cover in more than one sense of the word. The recreation of an early 20th-century photograph album is achieved primarily by the use of appropriate colors for the period. The hand-marbled effect of a period book, or album, is given greater authenticity by the choice of shades of brown, rather than different hues. The toning of fawn into the intensities of Havana brown suggests the era, while the monochrome photography and handwritten text are given visibility.

▲ This design has a contemporary originality which draws on other periods without sacrificing modern individuality. Pastels have been taken into a subterranean palette, as four discordant shades complement one another while vying for visibility.

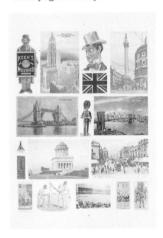

A montage of period scenes of England is given unity and authenticity by the muted palette of pastel shades. These soft yellowed tones from the red family create the illusion of sepia and age without losing impact.

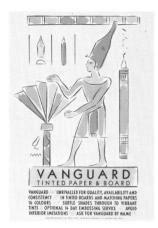

Ancient Egypt is captured in the pastel palette. The graphic images are true in feeling and style to the wall decorations of this early civilization. The liveliness of the pastel shades is further activated by the choice of cadmium primrose against oxblood for the title banner. The background of a low percentage yellow tint gives warmth while defining the "wall" background.

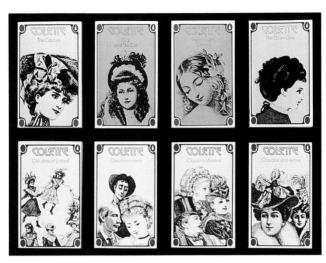

▲ This Art Deco design is entirely faithful to the colors that were in vogue during the 1920s and Thirties: shell pink, aqua, and primrose on black. The days when shopping was enjoyed in a more leisurely way are recreated within this design through graphics and color imagery.

A series of books by Colette have illustrative portraits as the cover graphics. They set the period immediately with the quiet authority given by the appropriate colors. The combination of illustrative content and the chosen colorways creates two series. The first "series" has a single portrait which has been given individuality by the application of a single pastel shade. These pastels harmonize but retain their own character. The second "series" has several portraits on each cover, while retaining the theme of black on white. The two "series" are connected by the burnt orange of the publisher's logo in one corner that is echoed in the other three corners.

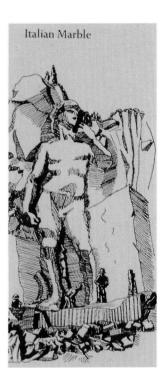

▲ Renaissance Italy is portrayed in marble. By applying linear graphics onto the color of marble, the designer has created a strong imagery for the product in the subtlest of ways. The shell pink background allows the black image to form a textural effect while retaining the coloration of marble.

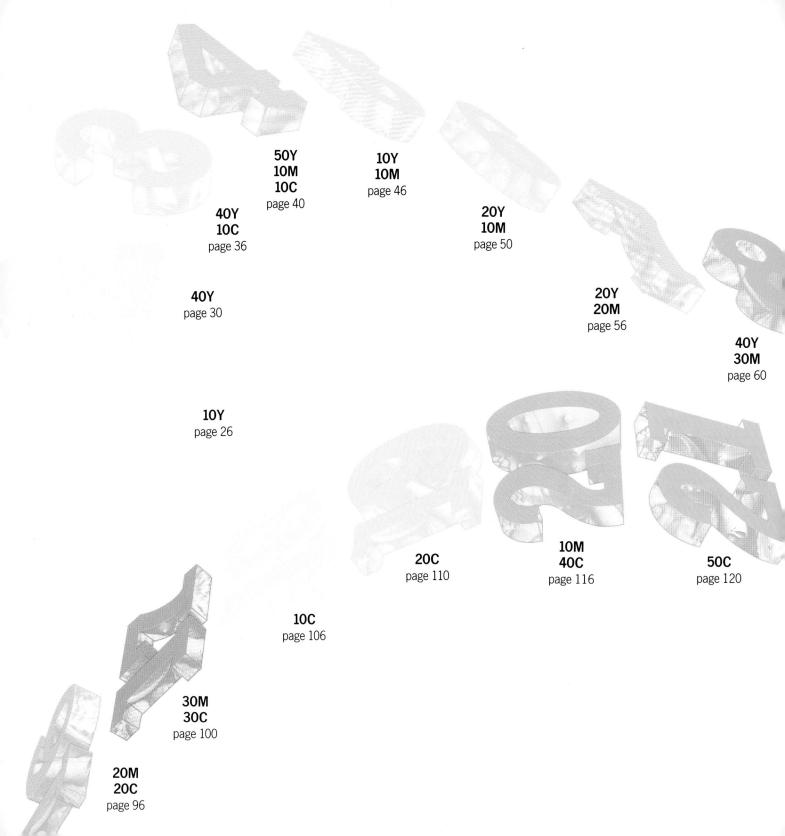

20M page 74

10M page 70

20M 10C page 92

40Y 30M 20C page 64

THE COLORS

Numbers are percentages

10Y 10C

page 126

20Y 20C page 130

> **40Y 30C** page 134

30Y 40C page 138

Pink				opgrs xyzde opgrs ZA GHIJ PQRS XYZA	ghijki uvwxg LDE (LMN TUVM 3CDE	zabed nnopi zabed A AHIJ OPQR XYZA GHIJ	fgbijk fgbijk .MN STUV BCDE (LMN	lmnot exyzal mnop QR. (XYZ) GHIJI)PQR.	grstur cdefgk grstur UVV BCDE LMN TUVV	ijklmi vxyza X XYZA FGHL PPQRI XYZA		oijkln uvux oijkln sHl. OPQI XYZI
Cream	Numbers are percentages	10Y	40Y	POR VXYA UVW 40Y 10C	TUV ABC XYZ 50Y 10M 10C	SCD VXYZ DEFG BCD	ABCA HIJKA BFGH	E. Bry	KS XIOF HIJKI PQRS INOF 40Y 30M	MNG	PORS XXXZ VVW.	TUV ABCI CYZA

30M	20M 30BLK	10M 10C	20M 10C	20M 20C	30M 30C	10C	20C	10M 40C	50C	10Y 10C	20Y 20C	40Y 30C	30Y 40C	
10.7	IJKL DEF		QRS7 NOPÇ					JKLN GHIJ			STU	WX.	ZAB	
ZAB.	BCD		IJĸĹ	INOF	QRS7			BCDI	FGH			PRST		
JH AFG			ST					A HI,				AWX		
	JKLM		?S7U	WXY2	ABCL			VOPÇ		WXY.	'ABCI	EFGH	UKLN	
			'ABCI IKLM					EFGH				WXY		
JOPC	XLM	JPQ	JTU	JXYZ	BCL			OPÇ /WXY	STU		BC	.rGI INOP	KLA	
	SERVICE DE L'ANGEL DE		M	and a supplemental	ANGERSONSSISSISSISSISSISSISSISSISSISSISSISSISSI							1/4	000000000000000000000000000000000000000	
Service Control			bqrsta gbijkl		4			vwxy: jklmr				rstuvi fghijk		
rstuvi	exyzat		qrstu ghijki	nnope	rstuvi			wxy2 jklmi	opgrsi		rabed	stuvi fghijk	mnop	
	al		jkl	pq	vi			hr.				jk		
			ghijk.					607	7		The second secon	ocdef		
			ghijk stuvw.									nopq		
Zabi	efgl		ávw.	zab	efgl			yza	def		lopr	lopq	avv	
RCD	CDF		INOI	ODST	TANK			TECH	TELA		DOT	NAWA A	VZA.	
EFG	ABC HIJK		HIJK PQRS	TUV	PQKS ZXYZ			ABCI HJKI	MNO.		UVW	'QRS' XYZ	BCD	
BCD	CDE		INOI	QRST	UVW			FGH	JKLA		PRST	JVW.	YZA	
AG	JK		∠R!	JVI	SYZ			/KI	NO		VV	XZ.	€D.	

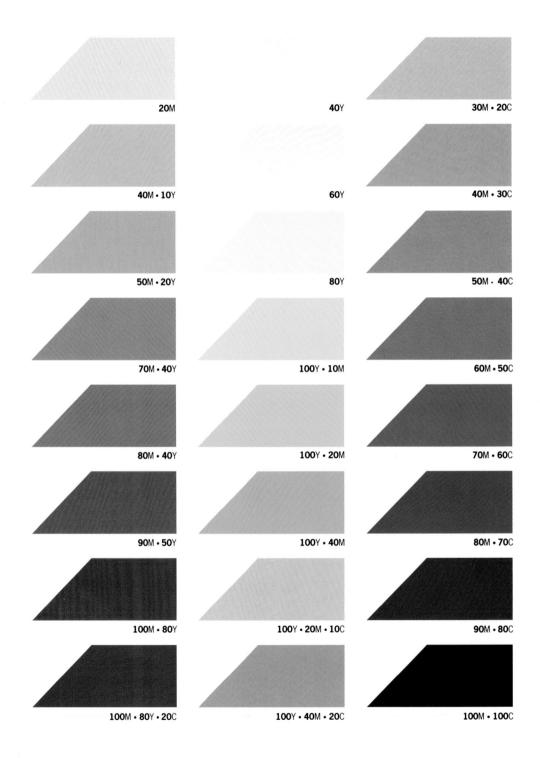

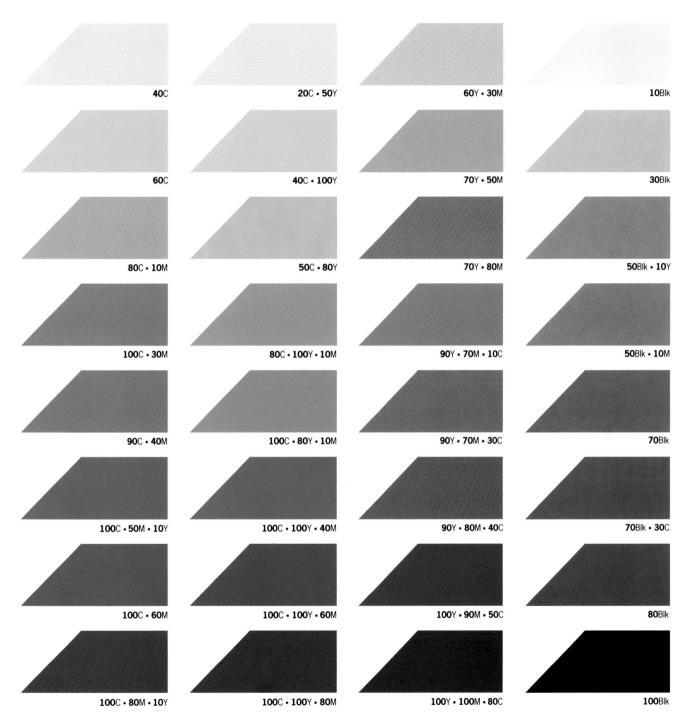

Ossidet sterio binignuis tultia, dolorat isogult it gignuntisin stinuand. Flourida prat gereafiunt quaecumque trutent artsquati, quiateire lurorist de corspore orum semi uitantque tueri; sol etiam caecat contra osidetsal utiquite

Ossidet sterio binignuis tultia, dolorat isogult it gignuntisin stinuand. Flourida prat gereafiunt quaecumque trutent artsquati, quiateire lurorist de corspore orum semi uitantque tueri; sol etiam caecat contra osidetsal utiquite

100Blk H/T • H/T's: 10Y

100Blk H/T • H/T's: 5Y

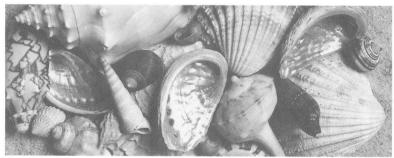

Blk H/T • H/T's: **10**Y

Blk H/T • H/T's: **5**Y

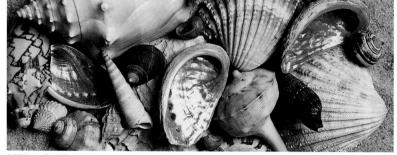

100Blk H/T • F/T's: 10Y

100Blk H/T • F/T's: 5Y

H/T's: **10**Y

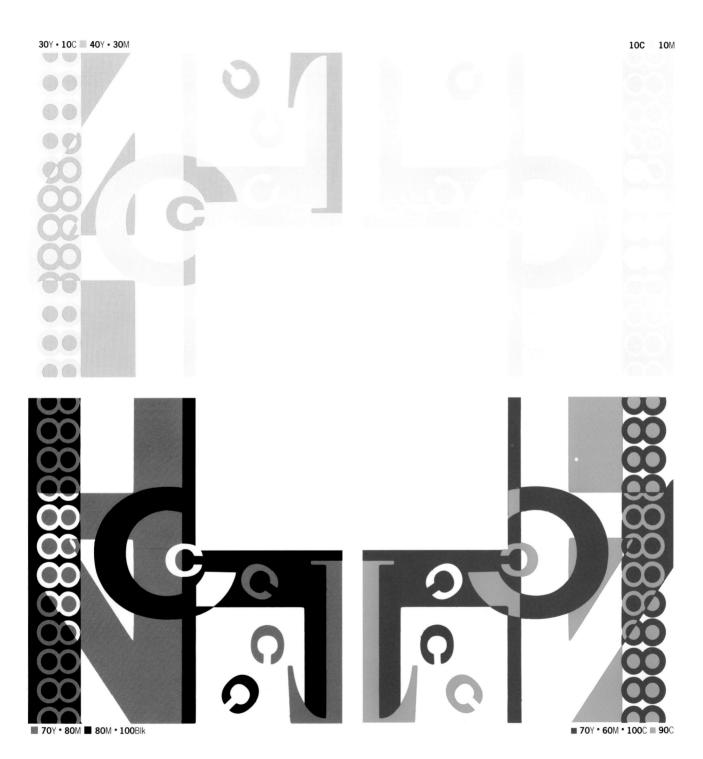

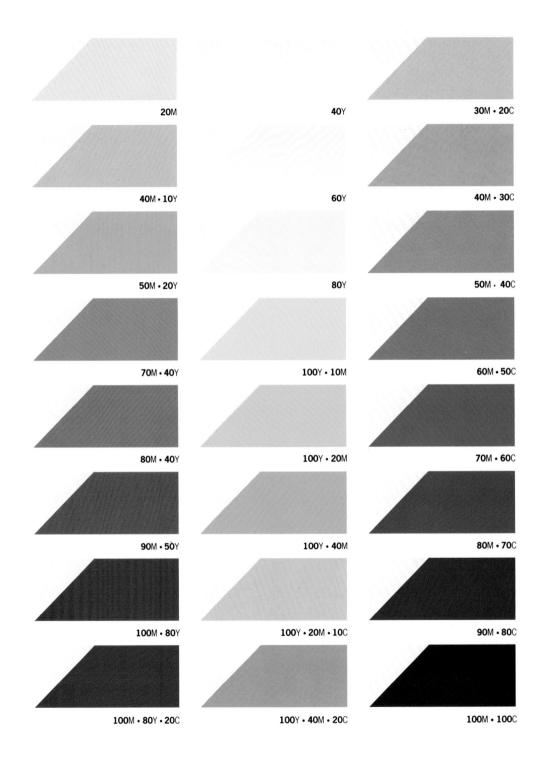

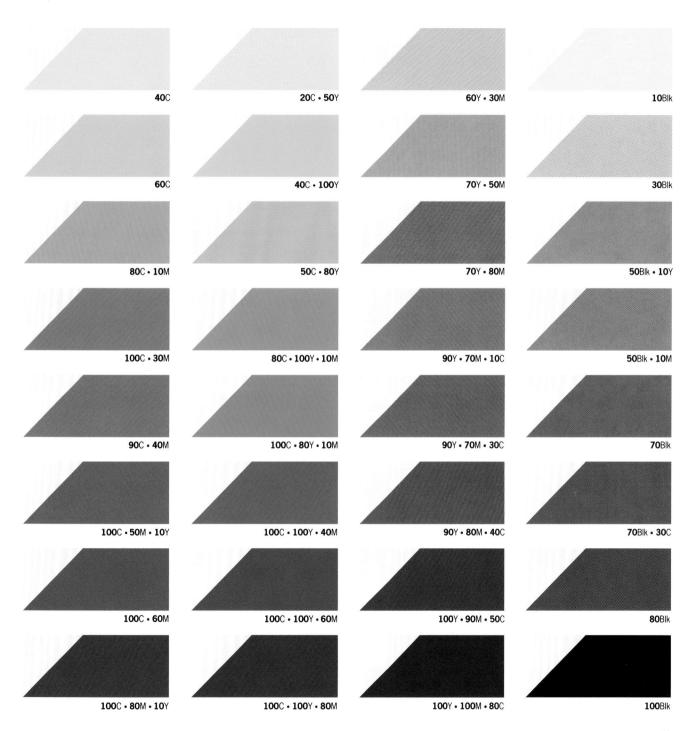

Ossidet sterio binignuis tultia, dolorat isogult it gignuntisin stinuand. Flourida prat gereafiunt quaecumque trutent artsquati, quiateire lurorist de corspore orum semi uitantque tueri; sol etiam caecat contra osidetsal utiquite

Ossidet sterio binignuis tultia, dolorat isogult it gignuntisin stinuand. Flourida prat gereafiunt quaecumque trutent artsquati, quiateire lurorist de corspore orum semi uitantque tueri; sol etiam caecat contra osidetsal utiquite

100Blk H/T • H/T's: 40Y

100Blk H/T • H/T's: 20Y

Blk H/T • H/T's:**40**Y

Blk H/T • H/T's: **20**Y

100Blk H/T • F/T's: 40Y

100Blk H/T • F/T's: 20Y

■ 60Y • 40M • 10Blk **■ 60**Y • 100M • 40C • 40Blk

■ 40Y • 90C • 10Blk ■ 70M • 30C

The faintest tint of yellow creates texture when white is too harsh, harmonizes with shades of green and black, and is a perfect foil for red.

In keeping with a book on calligraphy, the combination of pattern with such a gentle shade of yellow becomes evocative of the textural effect of handmade paper.

The palest of cream tints forms a sympathetic background for the soft green and crimson of the botanical illustration. When combined with the classic black typeface it creates a restrained and traditional dust jacket.

Immediate product recognition is achieved through the application of yellow which is generally associated with dairy products. This shade of primrose, combined with the powerful use of pastel graphics creates an atmosphere of alfresco eating on a sunny day.

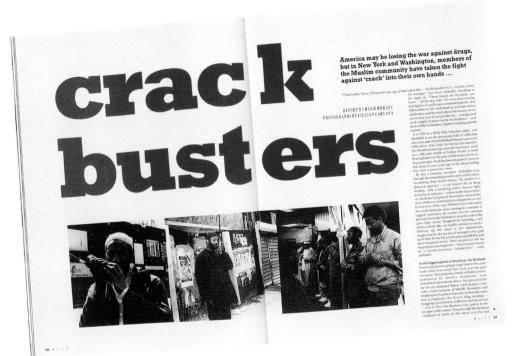

Blood-red typography on a pure cream tint is symbolic of blood spilled through drug abuse and the color of illegal drugs. This choice of background gives power and clarity to the type, while lending a strong atmosphere of photorealism to the monochrome photography.

This color combination evokes the 1940s but has a contemporary application. A linear approach to a color palette of black, white, and kingfisher, with hints of palest yellow, is immediately suggestive of the underwater scene so atmospherically portrayed. The palest of lemon yellows forms the bright central spotlight.

An industrial approach to a nautical theme and color combination allows both a forceful typographic statement and strong graphic illusion. An application of ten percent process yellow against sage green suggests underwater lighting. The soft, glowing yellow light projects the black type within the porthole, yet when these colors are reversed still brings clarity to the typography in this contemporary design.

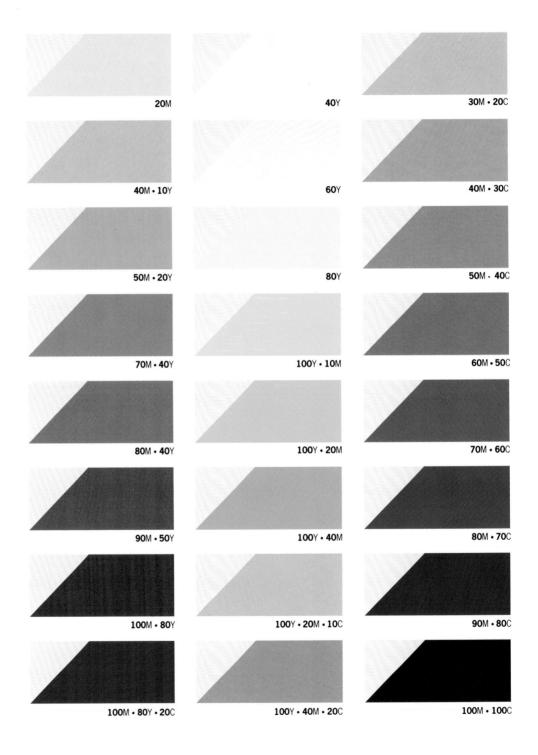

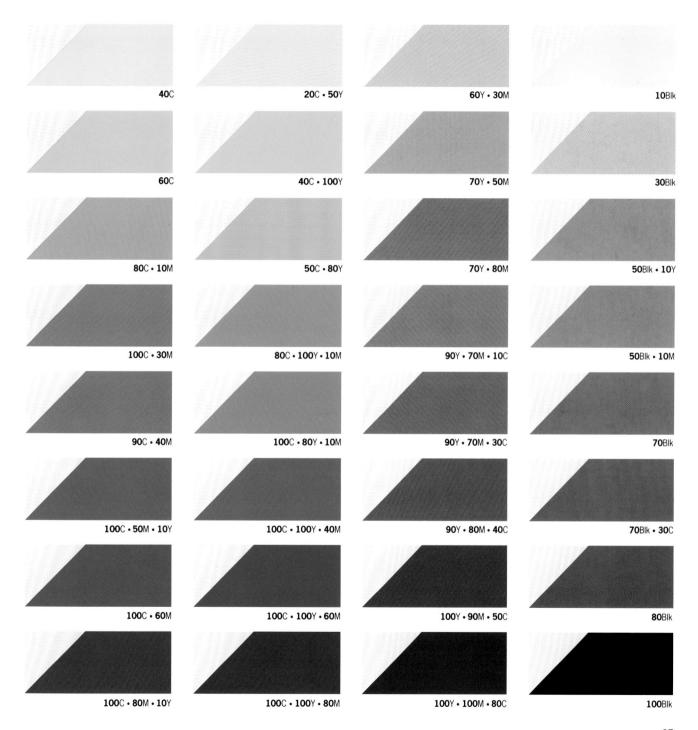

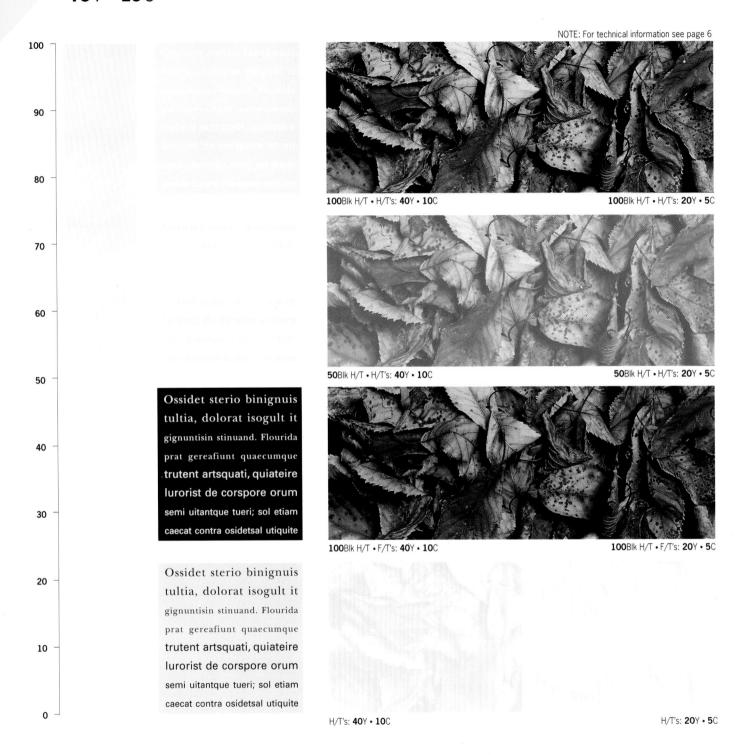

Y • **10**M • **10**C

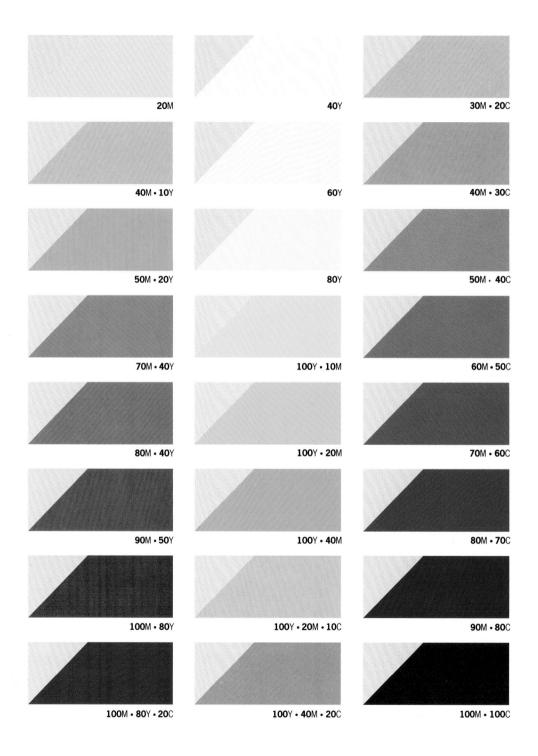

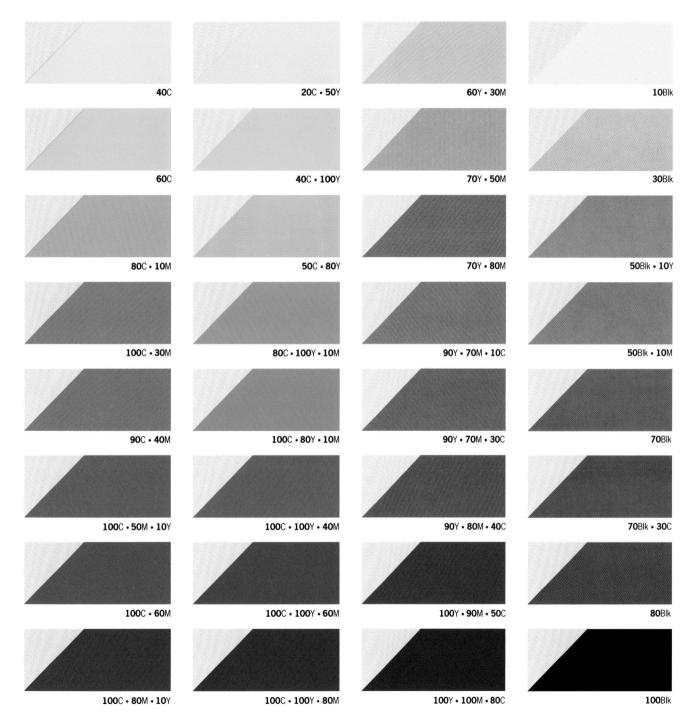

50Y • **10**M • **10**C

NOTE: For technical information see page 6 100 90 80 100Blk H/T • H/T's: 50Y • 10M • 10C 100BJk H/T • H/T's: 25Y • 5M • 5C 70 60 50Blk H/T • H/T's: 50Y • 10M • 10C 50Blk H/T • H/T's: 25Y • 5M • 5C 50 Ossidet sterio binignuis tultia, dolorat isogult it gignuntisin stinuand. Flourida 40 prat gereafiunt quaecumque trutent artsquati, quiateire lurorist de corspore orum semi uitantque tueri; sol etiam 30 caecat contra osidetsal utiquite 100Blk H/T • F/T's: 50Y • 10M • 10C 100Blk H/T • F/T's: 25Y • 5M • 5C Ossidet sterio binignuis 20 tultia, dolorat isogult it gignuntisin stinuand. Flourida prat gereafiunt quaecumque 10 trutent artsquati, quiateire lurorist de corspore orum semi uitantque tueri; sol etiam caecat contra osidetsal utiquite 0 H/T's: 50Y • 10M • 10C H/T's: 25Y • 5M • 5C

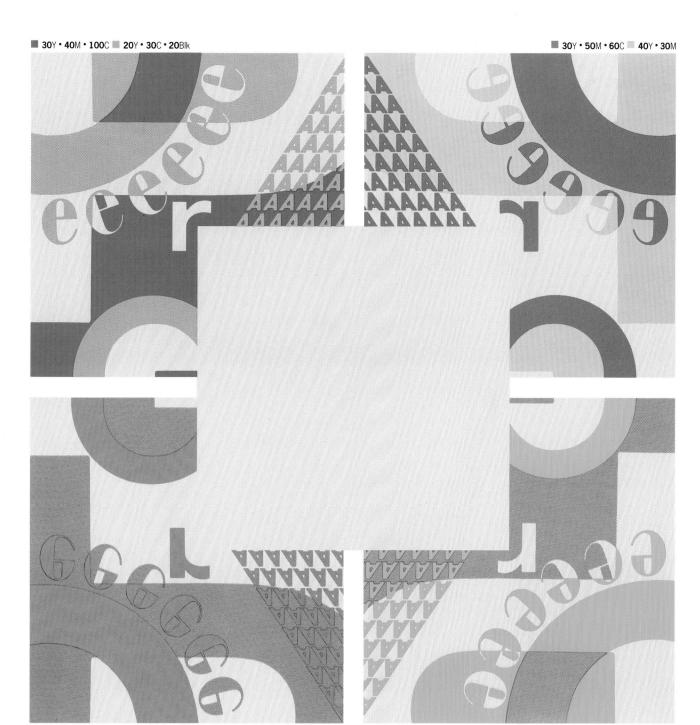

Acrid shades of yellow and lime soften to become the embodiment of citrus fruits. These shades are perfect companions for monochrome imagery.

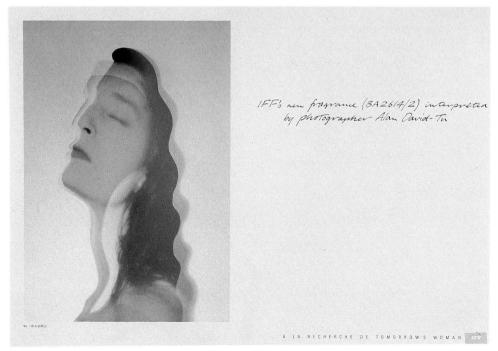

A handprinted textured application of fudge on ecru is reminiscent of Arts and Crafts rather than commercial design. Yellow on gray-patterned black for the typography ensures clarity of text and enhances the feel of the Arts and Crafts movement. Rose madder punctuates the sentences, echoing the page edging.

■ A surrealist approach to the displacement of color, light, and shadow forms a statement rather than a portrait. An aura of scent rises from the soft sepia tint of her hair; mustard lips, frozen in time, add a sense of mystery. These two shades blend together for the company logo, subtly placed on the timeless white of the facing page.

▲ The bold cadmium yellow issues an invitation to quench one's thirst, while the pale mint suggests that the ingredients are natural and refreshing. These colors, strengthened by black and white, create a traditional image with a modern approach.

by the striking use of chartreuse on white with minimalist black typography. This organic shade has great clarity when applied to a primitive design that is evocative of neolithic landscape figures, and is therefore appropriate for a landscape architect.

A Palest olive harmonizes with peach to create the illusion of changing intensities against the definition of deep olive green. The pastel musk

rose border gently clashes, increasing the strength of the peach background.

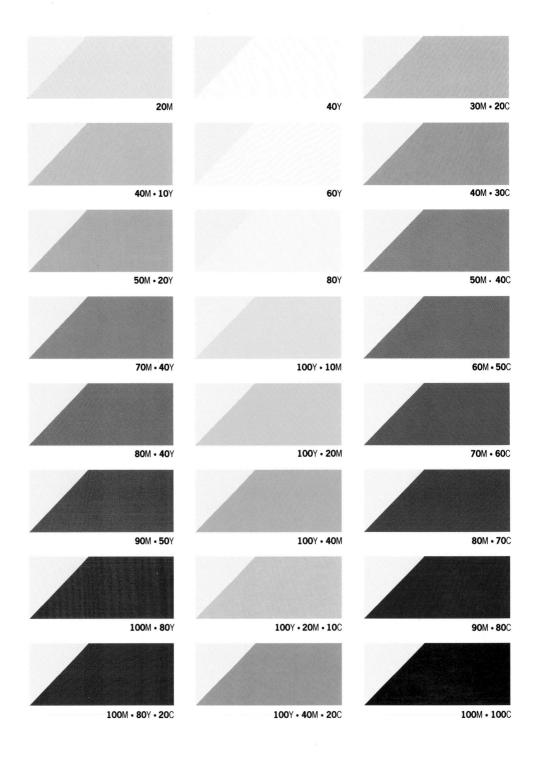

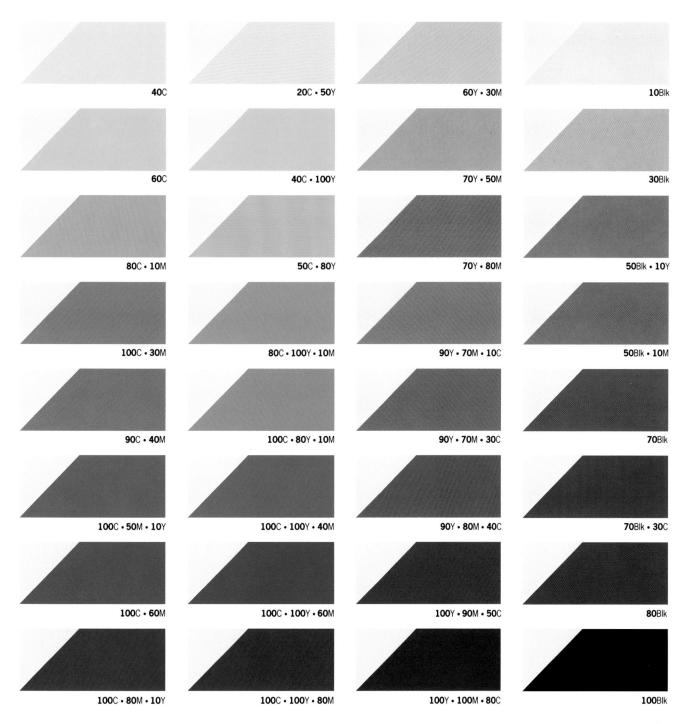

NOTE: For technical information see page 6 100 90 80 100Blk H/T • H/T's: 10Y • 10M 100Blk H/T • H/T's: 5Y • 5M 70 60 50Blk H/T • H/T's: 10Y • 10M 50 Ossidet sterio binignuis tultia, dolorat isogult it gignuntisin stinuand. Flourida 40 prat gereafiunt quaecumque trutent artsquati, quiateire lurorist de corspore orum semi uitantque tueri; sol etiam 30 caecat contra osidetsal utiquite 100Blk H/T • F/T's: 10Y • 10M 100Blk H/T • F/T's: 5Y • 5M Ossidet sterio binignuis 20 tultia, dolorat isogult it gignuntisin stinuand. Flourida prat gereafiunt quaecumque trutent artsquati, quiateire 10 lurorist de corspore orum semi uitantque tueri; sol etiam caecat contra osidetsal utiquite 0 H/T's: 10Y • 10M H/T's: 5Y • 5M

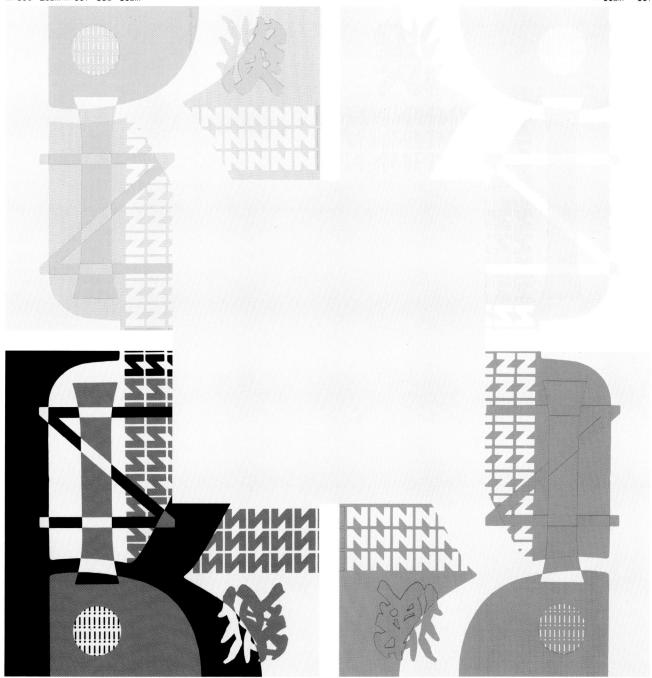

Y • 60M • 30Blk ■ 100M • 90Blk

Y • 40M • 20Blk **40**Y • 50C • 20Blk

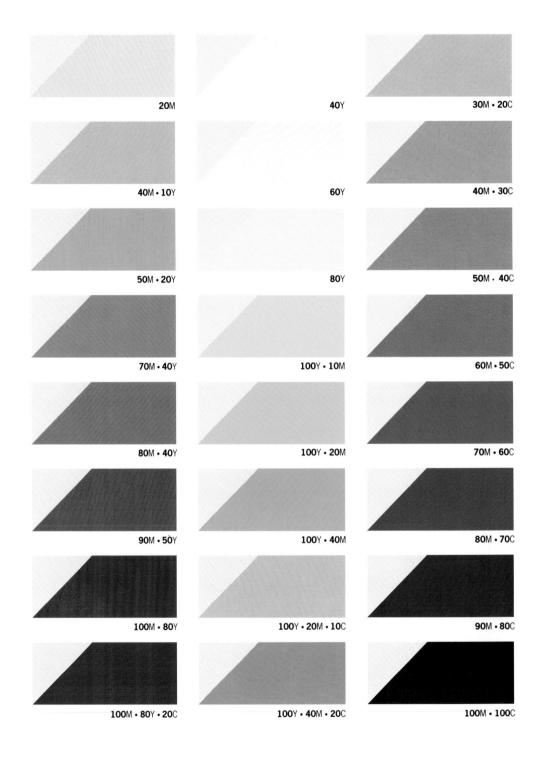

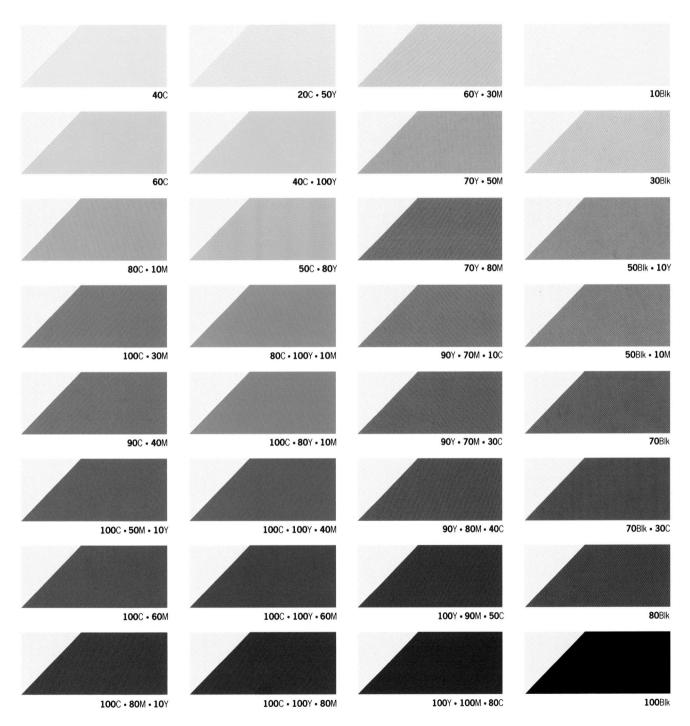

NOTE: For technical information see page 6 100 90 80 100Blk H/T • H/T's: 20Y • 10M 100Blk H/T • H/T's: 10Y • 5M 70 60 50Blk H/T • H/T's: 20Y • 10M **50**Blk H/T • H/T's: **10**Y • **5**M 50 Ossidet sterio binignuis tultia, dolorat isogult it gignuntisin stinuand. Flourida 40 prat gereafiunt quaecumque trutent artsquati, quiateire lurorist de corspore orum semi uitantque tueri; sol etiam 30 caecat contra osidetsal utiquite 100Blk H/T • F/T's: 20Y • 10M 100Blk H/T • F/T's: 10Y • 5M Ossidet sterio binignuis 20 tultia, dolorat isogult it gignuntisin stinuand. Flourida prat gereafiunt quaecumque 10 trutent artsquati, quiateire lurorist de corspore orum semi uitantque tueri; sol etiam caecat contra osidetsal utiquite 0 H/T's: 20Y • 10M H/T's: 10Y • 5M

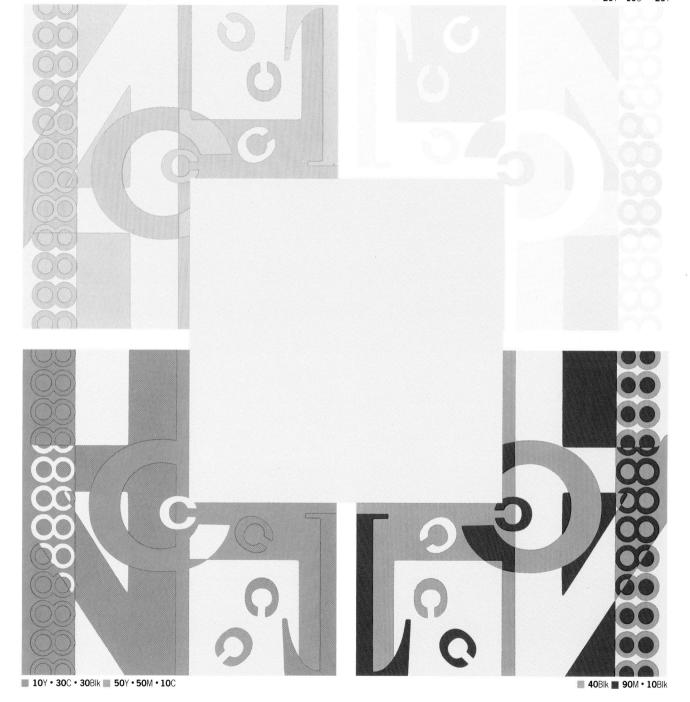

Creamy tones of purest marble, translucent flesh pink, whisked apricot, and warmest shades of magnolia form a family of versatile and distinctive colors.

The color and graphics of this lotion allow the moisturizer to be sold on its own merit without trying to appeal exclusively to either men or women. The apricot on the label intensifies the color of the lotion, while the dove gray harmonizes with the contents. The teal graphics and type project a feeling of strength and cleanliness when placed against the white and apricot.

Ultramarine projects the image of Holly Johnson and makes the title lettering float. The bold peach on the strong blue background has great clarity, harmonizing with the complexion of the figure on the opposite page. This unconventional color combination has a contemporary feel, while giving the page layout impact and visibility.

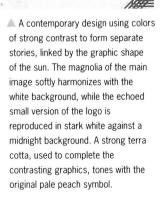

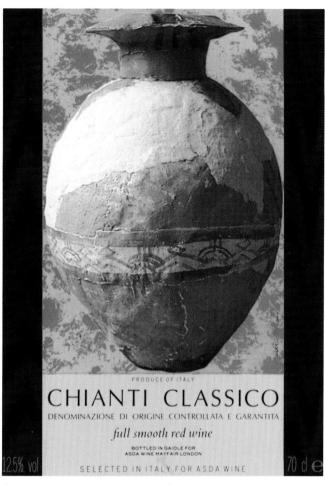

▲ The weathered earthen hues and texture of the vase are echoed in the pink and gold background. The beauty of classic design against a rich Italian-style decor is underlined by the choice of peach for the typography's backdrop. The black is balanced by solid black columns framing the image.

The use of pastels for a computer wares brochure is both adventurous and eyecatching. The soft apricot background allows two color schemes to coexist. Nursery blue and pink become positive when projected from white graphics. The unusual combination of teal and terracotta, again with white, adds a discreet note to the stronger pastels.

▲ A product made from natural ingredients uses soft, natural colors, in keeping with the emblem of the World Wildlife Fund – an international conservation body. This application of

traditional colors is given an original touch by using orange to set off the greens of both the lettuce and the fern against the pale peach.

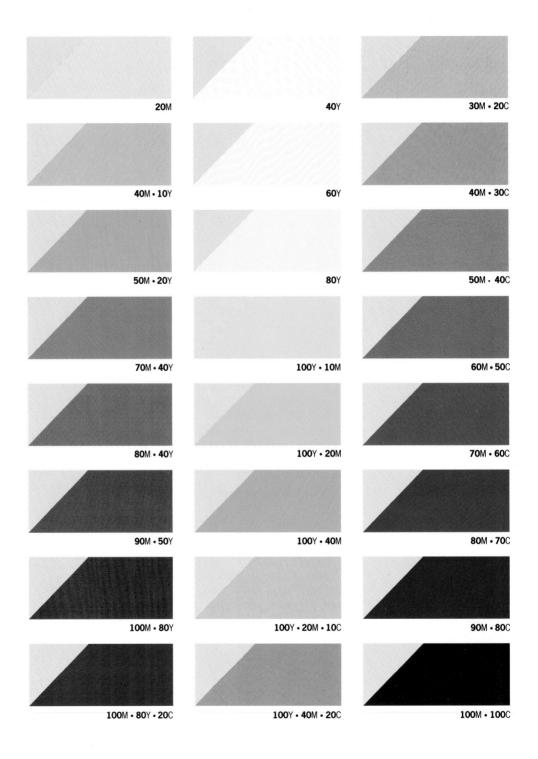

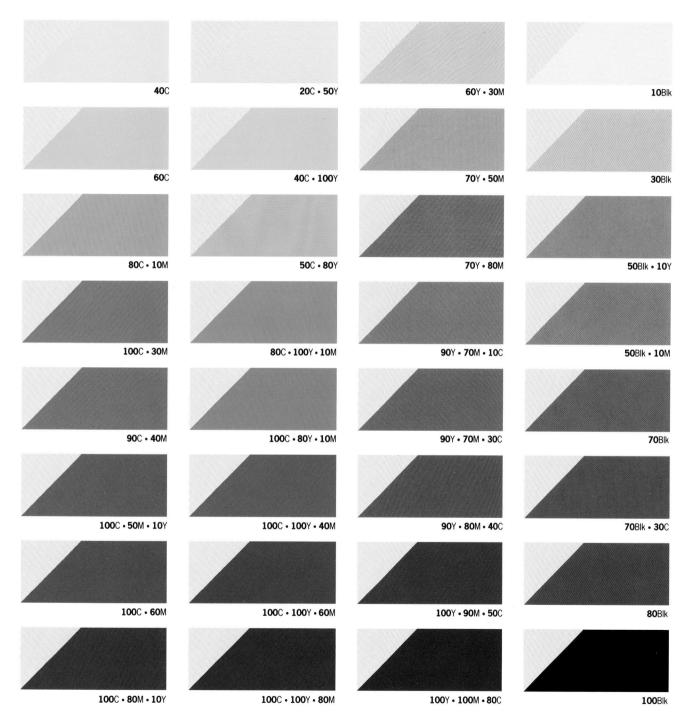

0

Ossidet sterio binignuis tultia, dolorat isogult it gignuntisin stinuand. Flourida prat gereafiunt quaecumque trutent artsquati, quiateire lurorist de corspore orum semi ultantque tueri; sol etiam caecat contra osidetsal utiquite

Ossidet sterio binignuis tultia, dolorat isogult in gignunisia stimand. Flourida prar gereafiunt quaecumque trutent artsquati, quiateire lurorist de corspore orum semi ultanque tueri; sol etiam caecal contra osidetsal utiquite

Ossidet sterio binignuis tultia, dolorat isogult it gignuntisin stinuand. Flourida prat gereafiunt quaecumque trutent artsquati, quiateire lurorist de corspore orum semi uitantque tueri; sol etiam caecat contra osidetsal utiquite

Ossidet sterio binignuis tultia, dolorat isogult it gignuntisin stinuand. Flourida prat gereafiunt quaecumque trutent artsquati, quiateire lurorist de corspore orum semi uitantque tueri; sol etiam caecat contra osidetsal utiquite

NOTE: For technical information see page 6

100Blk H/T • H/T's: 20Y • 20M

100Blk H/T • H/T's: 10Y • 10M

50Blk H/T • H/T's: 20Y • 20M

50Blk H/T • H/T's: 10Y • 10M

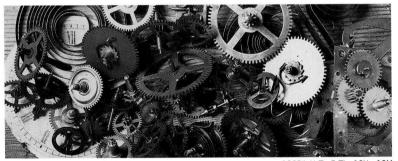

100Blk H/T • F/T's: 20Y • 20M

100Blk H/T • F/T's: 10Y • 10M

H/T's: 20Y • 20M

H/T's: 10Y • 10M

30M • 30Blk 10Y • 100M • 40Blk

■ 60Y • 70M • 20Blk ■ 40Y • 40M • 20C • 10Blk

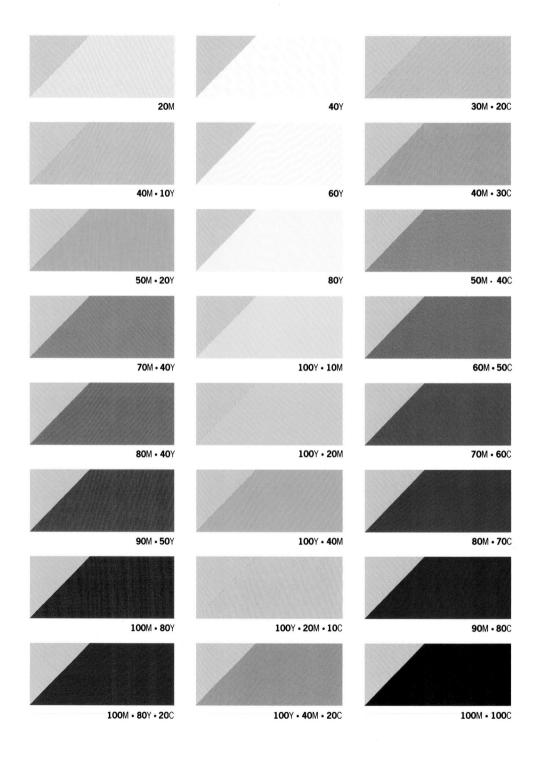

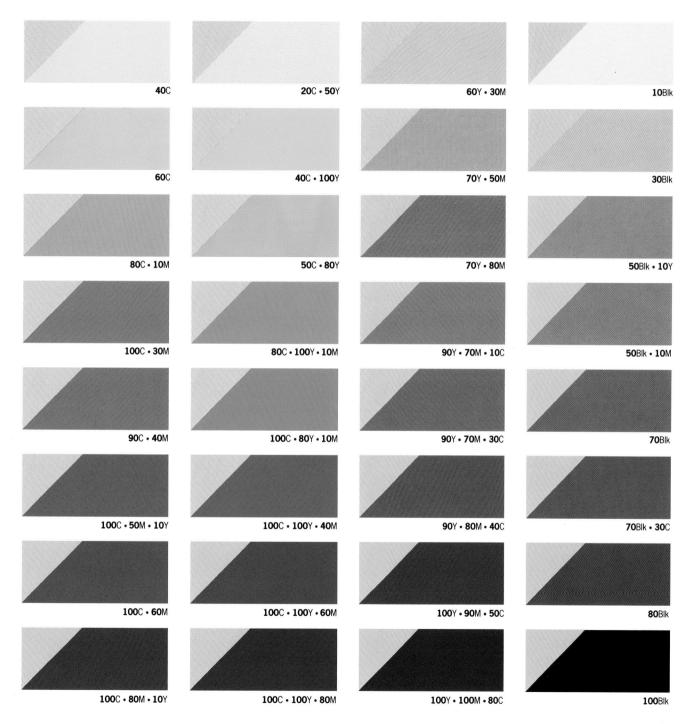

Ossidet sterio binignuis tultia, dolorat isogult it gignuntism stinuand. Flourida prat gereafiunt quaecumque trutent artsquati, quiateire lurorist de corspore orum semi uitantque tueri; sol etiam caecat contra osidetsal utiquite

Ossider sterio binignuis tultia, dolorat isogult it gignuntisin stinuand. Flourida prai gereafiunt quaecumque trutent artsquati, quiateire lurorist de corspore orum semi uitantque tueri; sol etiam caecat contra osidetsal utiquite

Ossidet sterio binignuis tultia, dolorat isogult it gignuntisin stinuand. Flourida prat gereafiunt quaecumque trutent artsquati, quiateire lurorist de corspore orum semi uitantque tueri; sol etiam caecat contra osidetsal utiquite

Ossidet sterio binignuis tultia, dolorat isogult it gignuntisin stinuand. Flourida prat gereafiunt quaecumque trutent artsquati, quiateire lurorist de corspore orum semi uitantque tueri; sol etiam caecat contra osidetsal utiquite

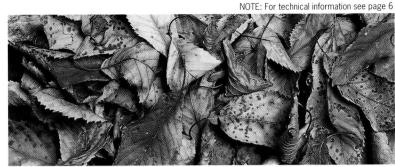

100Blk H/T • H/T's: 40Y • 30M

100Blk H/T • H/T's: 20Y • 15M

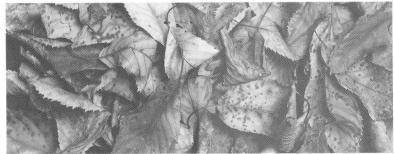

50Blk H/T • H/T's: **40**Y • **30**M

50Blk H/T • H/T's: 20Y • 15M

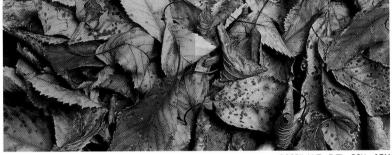

100Blk H/T • F/T's: 40Y • 30M

100Blk H/T • F/T's: 20Y • 15M

H/T's: 40Y • 30M

H/T's: 20Y • 15M

■ 100Y • 60M ■ 70Y • 70M • 10C • 40Blk

■ 50Y • 50C ■ 40M • 40C • 10Blk

Y • **30**M • **20**C

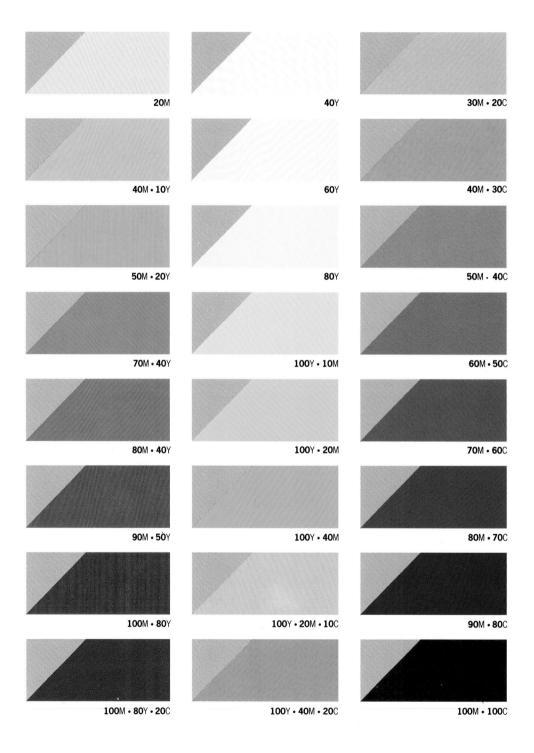

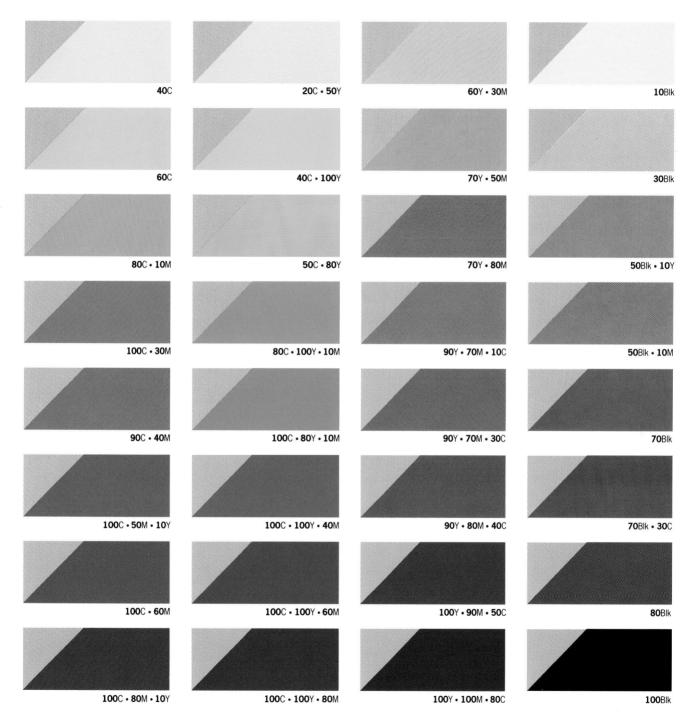

Ossidet sterio binignuis tultia, dolorat isogult it gignuntisin stinuand. Flourida prat gereafiunt quaecumque trutent artsquati, quiateire lurorist de corspore orum semi uitantque tueri; sol etiam caecat contra osidetsal utiquite

Ossidet sterio binignuis tultia, dolorat isogult it gignuntisin stinuand. Flourida prat gereafiunt quaecumque trutent artsquati, quiateire lurorist de corspore orum semi ultantque tueri; sol etiam caecat contra osidetsal utiquite

Ossidet sterio binignuis tultia, dolorat isogult it gignuntisin stinuand. Flourida prat gereafiunt quaecumque trutent artsquati, quiateire lurorist de corspore orum semi uitantque tueri; sol etiam caecat contra osidetsal utiquite

Ossidet sterio binignuis tultia, dolorat isogult it gignuntisin stinuand. Flourida prat gereafiunt quaecumque trutent artsquati, quiateire lurorist de corspore orum semi uitantque tueri; sol etiam caecat contra osidetsal utiquite

100Blk H/T • H/T's: 40Y • 30M • 20C

100Blk H/T • H/T's: 20Y • 15M • 10C

NOTE: For technical information see page 6

50Blk H/T • H/T's: **40**Y • **30**M • **20**C

50Blk H/T • H/T's: **20**Y • **15**M • **10**C

100Blk H/T • F/T's: 40Y • 30M • 20C

100Blk H/T • F/T's: 20Y • 15M • 10C

H/T's: 40Y • 30M • 20C

H/T's: **20**Y • **15**M • **10**C

30Y 10M • 10Blk

30C • 30Blk ■ 100M • 100C

■ 50Y • 100M ■ 40Y • 50M • 100C

Salmon, caramel, and soft bronze - these tones bring warmth and life, in a gentle form, to the design. They easily respond to stronger hues such as cobalt, orange, and yellow, while quietly dominating pale aqua, black, or white.

An extremely powerful and bright but unconventional color palette combines the strength and youthfulness of basic primary shades with the originality of mixing primary and secondary hues. The flesh pink background contains toning shades of bronze and terra cotta which complement the cornflower blue while interplaying with mint and chrome yellow.

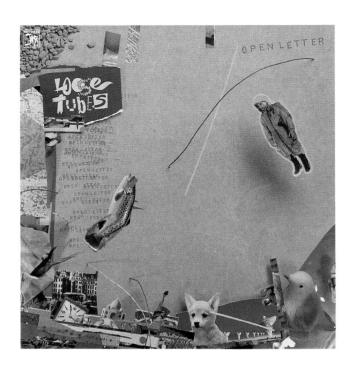

▲ The festive atmosphere of a wedding and warm San Franciscan nights are evoked by the depth and liveliness of this palest deep peach shade. The multicolor squares of confetti float on the peach, while silver gray calligraphy tones harmoniously. The pale primrose typography contrasts effectively with the pale background despite belonging to the same color "family."

■ This is a fresh and original approach to color specification – a strong peach has been applied to soft malachite. The addition of soft gray for the engraved border and type outlining enhances the almost luminous clarity of the peach.

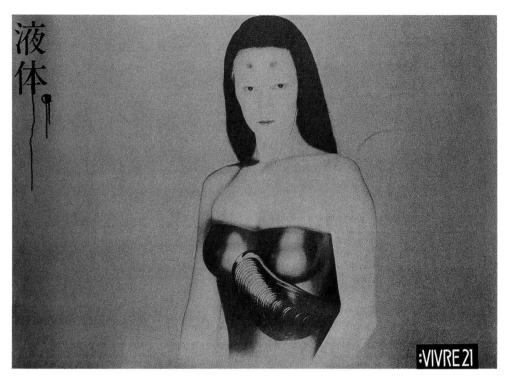

■ The strength of the flesh-pink tones against a sepia background has the effect of spotlighting the floating figure emerging apparently from nowhere. The powerful peach of the skin tones is reflected in the airbrushed black second skin enclosed by the menacing clam shell. Trailing black calligraphy against the sepia adds to the haunting atmosphere.

▼ A shell pink square of solid color is transformed into the flesh tones of a human face by the clever placing of the letters forming the word "face" The addition of white as a border strengthens the flesh pink color while making it recede; but when used to fill the letter E the white transforms it into teeth. The black typeface is projected by the flesh-toned square.

Sophistication is the key element in this application of the subtlest touch of white typography and a focal point of black minimalist design to a corporate brochure. Used in conjunction with ebony, the glowing warmth of the pink is reminiscent of powder blusher from the 1930s.

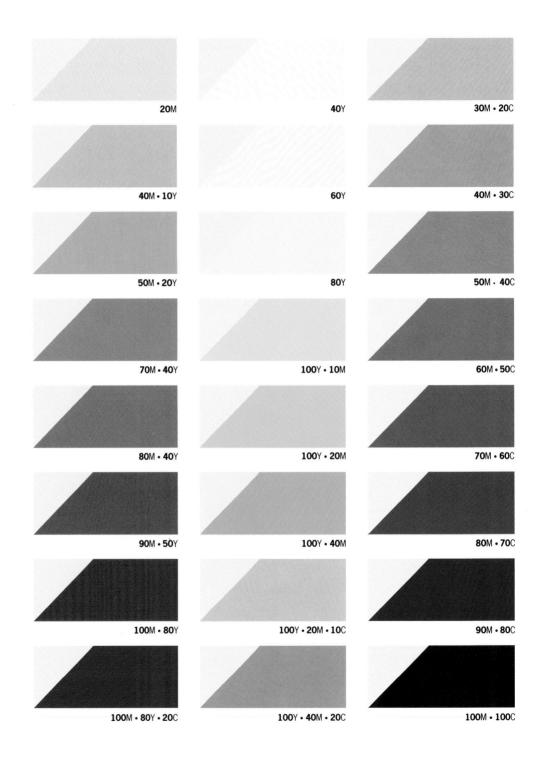

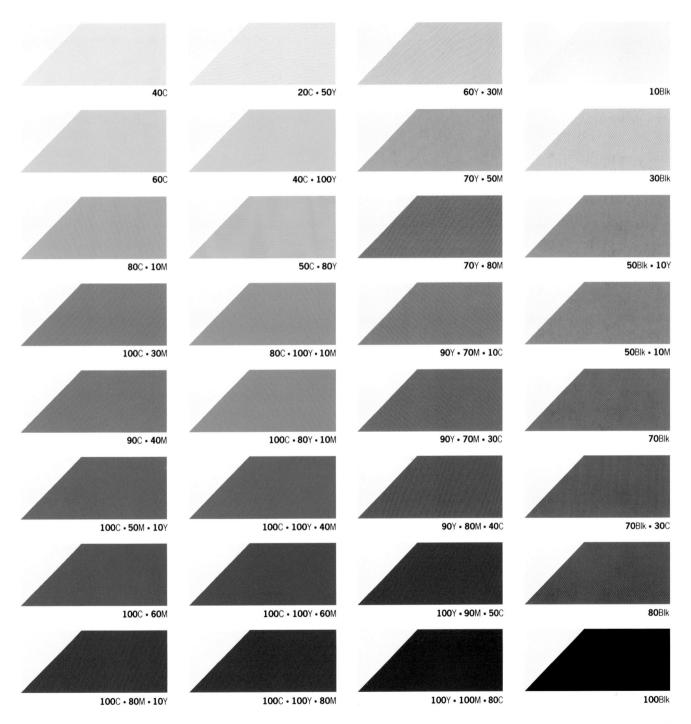

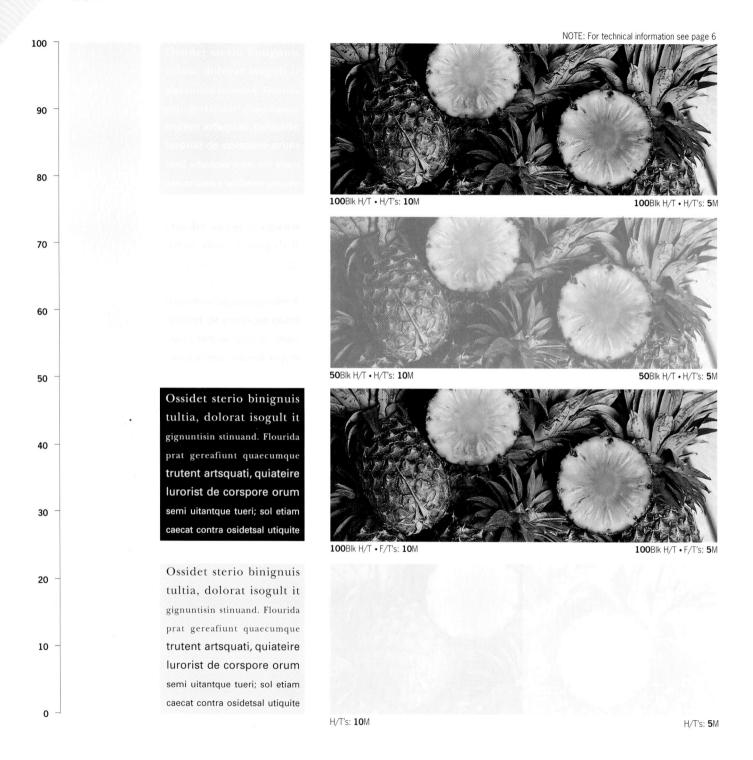

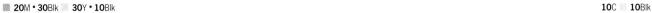

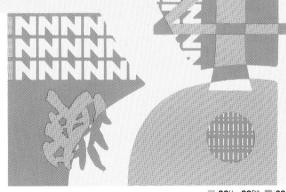

THILL!

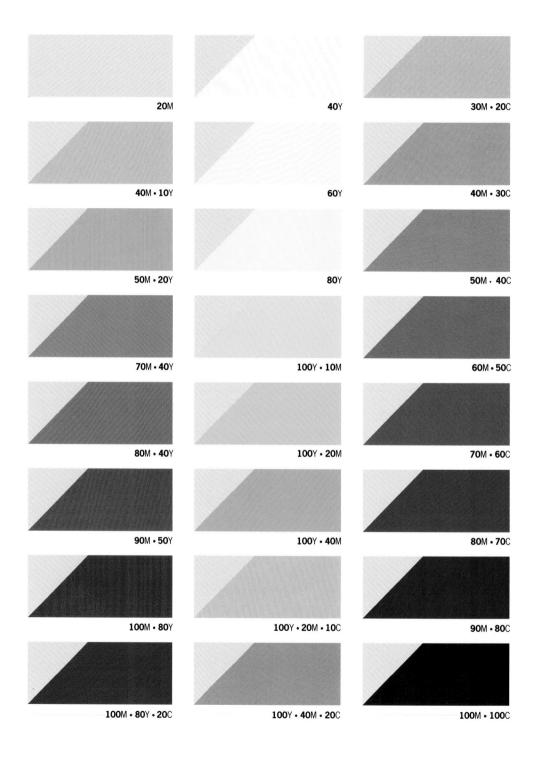

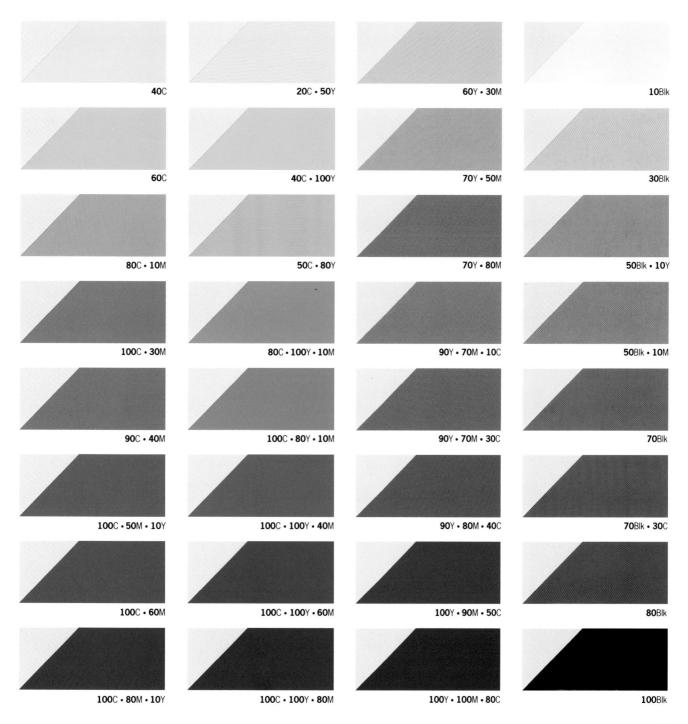

100 90 80 100Blk H/T • H/T's: 20M 70 60 50Blk H/T • H/T's: 20M 50 Ossidet sterio binignuis tultia, dolorat isogult it gignuntisin stinuand. Flourida 40 prat gereafiunt quaecumque trutent artsquati, quiateire lurorist de corspore orum semi uitantque tueri; sol etiam 30 caecat contra osidetsal utiquite 100Blk H/T • F/T's: 20M Ossidet sterio binignuis 20 tultia, dolorat isogult it gignuntisin stinuand. Flourida prat gereafiunt quaecumque 10 trutent artsquati, quiateire lurorist de corspore orum semi uitantque tueri; sol etiam caecat contra osidetsal utiquite 0 -H/T's: 20M

NOTE: For technical information see page 6

100Blk H/T • H/T's: 10M

50Blk H/T • H/T's: 10M

100Blk H/T • F/T's: 10M

H/T's: 10M

■ 20Blk ■ 40Y・100M・70C 30Y・10C 20Y

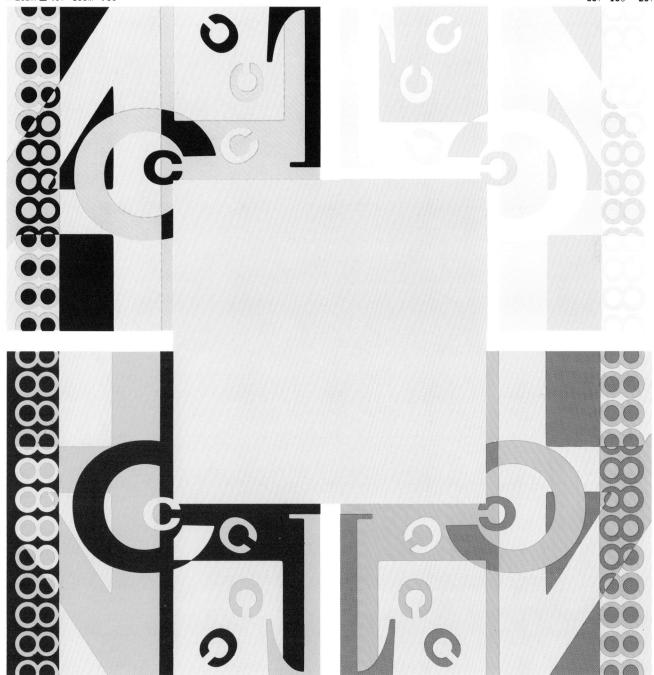

■ 90Y • 10M • 10Blk ■ 100M • 10Blk

■ 40Y • 50C ■ 40Y • 30M • 10C • 40Blk

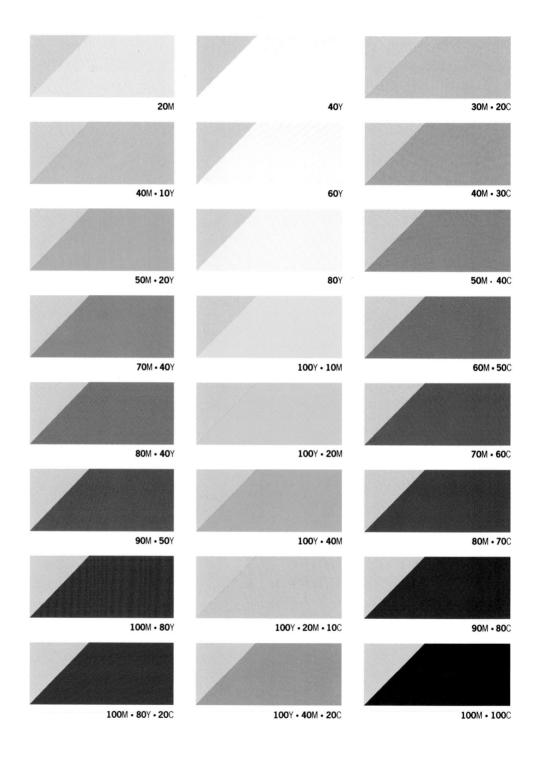

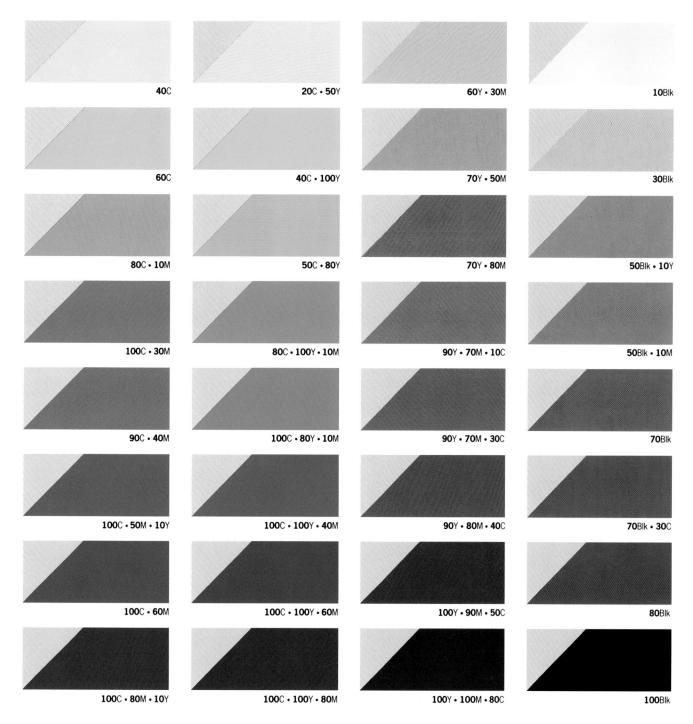

Ossidet sterio binignuis tultia, dolorat isogult it gignuntisin stinuand. Flourida prat gereafiunt quaecumque trutent artsquati, quiateire lurorist de corspore orum semi uitantque tueri; sol etiam caecat contra osidetsal utiquite

Ossidet sferio binignuis tultia, dolorat isogult it gignuntisin stimand. Flourida prat gereafium quaecumque trutent artsquati, quiateire lurorist de corspore orum semi uitantque tueri; sol etiam caecat contra osidetsal utiquite

Ossidet sterio binignuis tultia, dolorat isogult it gignuntisin stinuand. Flourida prat gereafiunt quaecumque trutent artsquati, quiateire lurorist de corspore orum semi uitantque tueri; sol etiam caecat contra osidetsal utiquite

Ossidet sterio binignuis tultia, dolorat isogult it gignuntisin stinuand. Flourida prat gereafiunt quaecumque trutent artsquati, quiateire lurorist de corspore orum semi uitantque tueri; sol etiam caecat contra osidetsal utiquite

100Blk H/T • H/T's: 30M

100Blk H/T • H/T's: 15M

50Blk H/T • H/T's: **30**M

50Blk H/T • H/T's: 15M

100Blk H/T • F/T's: **30**M

100Blk H/T • F/T's: 15M

H/T's:30M

H/T's: **15**M

80Y • 10M 20Y • 50C

■ 100Y • 90M • 10C **■ 100**M • 50C • 40Blk

Baby pink grows up. Pink can be enjoyed when taken out of context and used with sophisticated images or combined with unexpected colors. It can also be fully exploited within its natural range of colors and subjects.

▲ The soft pink of this 3-D integration of origami and cut-out brings a gentle elegance to the image. The use of mulberry for the shadowing gives a softness of focus and therefore a greater sense of dimension. The introduction of white adds a touch of clarity and becomes the main focal point.

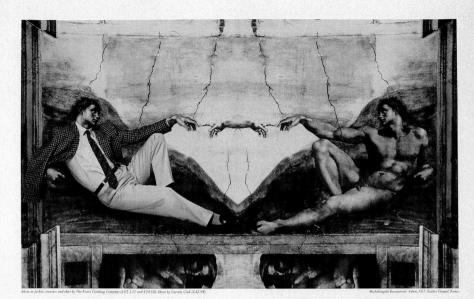

FAMOUS NUDES, DRESSED BY DICKINS & JONES.

▲ A ten percent magenta tint softens the entire monochrome image and through this process allows the clothed male to relate comfortably to the nude figure in the Old Master painting. The pastel tint harmonizes with the shades of the man's clothing.

■ This is pink used to its fullest extent. Children will immediately associate with the warmth and familiarity of candy pink and raspberry for the graphics, while the turquoise type gives the text clarity through contrast.

■ By combining silver with pink to form a checkerboard effect the designer has brought a degree of sophistication to the baby pink. The application of yellow adds a discordant note, enlivening the wrapper, while white gives visibility and emphasizes the purity of the product.

▼ An ethereal effect is achieved by emphasizing the purity of the blue sky with powder blue and pink for the borders and typography. The continuity of atmosphere through color is achieved by using a pink tint for the clouds. The clarity of the blue shades is enhanced by the reflecting silver.

▲ Two stories are told in this single image. The more obvious is the calendar, with minimal black typography against a stark white page linked by the interesting contrast of a pastel pink illustration. The second, more complex image is that of a face.

Purest white, soft baby pink, and Egyptian blue are instantly recognizable as representative of Johnson's baby products. The large expanse of white indicates the purity of the talc, while blue and pink give clarity to the typography and imply suitability of the product for both boys and girls.

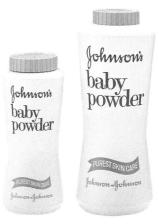

M • **30**Blk

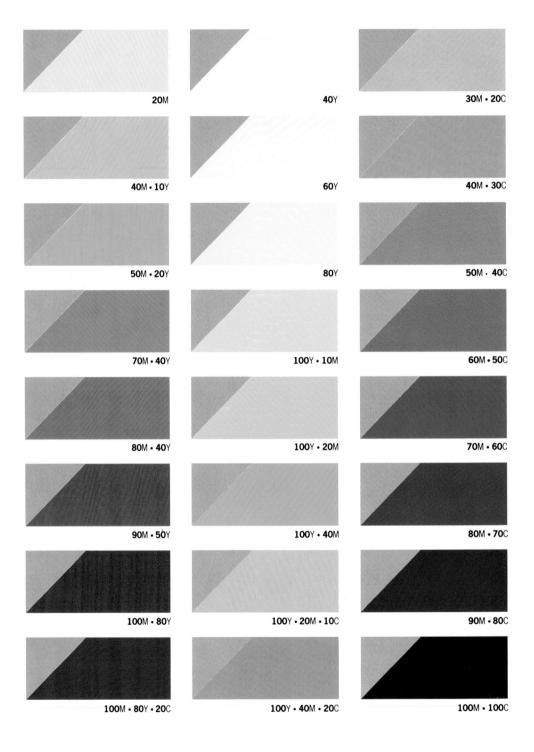

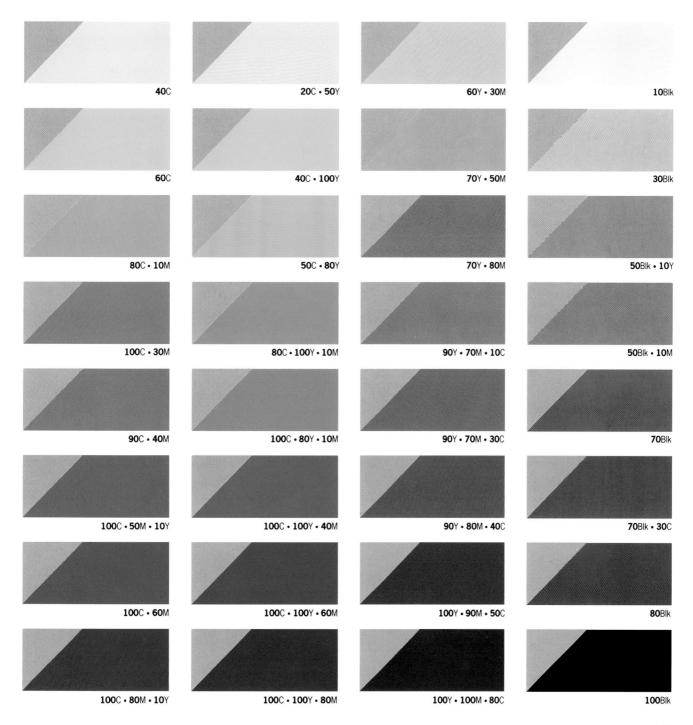

Ossidet sterio binignuis tultia, dolorat isogult it gignuntisin stinuand. Flourida prat gereafiunt quaecumque trutent artsquati, quiateire lurorist de corspore orum semi uitantque tueri; sol etiam caecat contra osidetsal utiquite

Ossidet sterio binignuis tultia, dolorat isogult it gignuntisin stinuand. Flourida prat gereafiunt quaecumque trutent artsquati, quiateire lurorist de corspore orum semi uitantque tueri; sol etiam caecat contra osidetsal utiquite

Ossidet sterio binignuis tultia, dolorat isogult it gignuntisin stinuand. Flourida prat gereafiunt quaecumque trutent artsquati, quiateire lurorist de corspore orum semi uitantque tueri; sol etiam caecat contra osidetsal utiquite

Ossidet sterio binignuis tultia, dolorat isogult it gignuntisin stinuand. Flourida prat gereafiunt quaecumque trutent artsquati, quiateire lurorist de corspore orum semi uitantque tueri; sol etiam caecat contra osidetsal utiquite

100Blk H/T • H/T's: 20M • 30Blk

100Blk H/T • H/T's: 10M • 15Blk

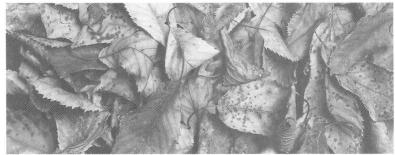

50Blk H/T • H/T's: 20M • 30Blk

50Blk H/T • H/T's: **10**M • **15**Blk

100Blk H/T • F/T's: 20M • 30Blk

100Blk H/T • F/T's: 10M • 15Blk

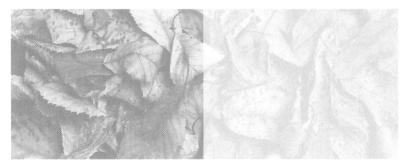

H/T's: **20**M • **30**Blk H/T's: **10**M • **15**Blk

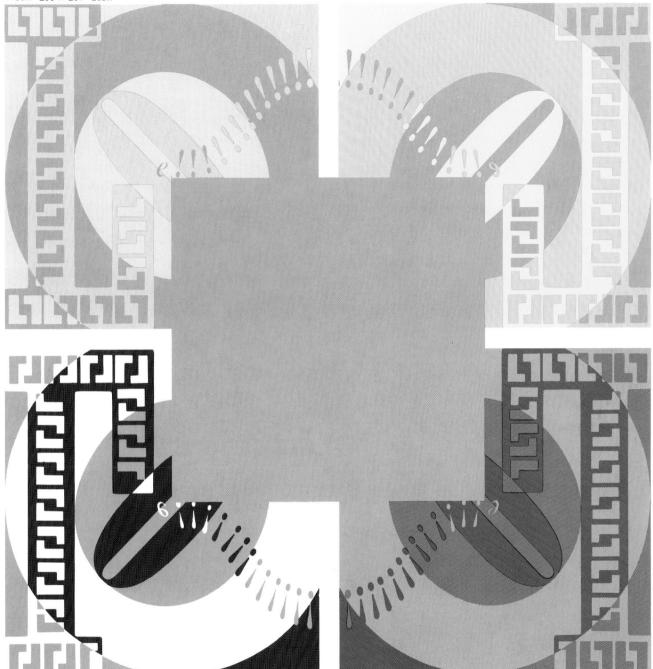

■ 80Y • 50M • 30Blk **■ 10**Y • 50M • 70C • 30Blk

WHITE **70**M • 70Blk

$\mathbf{10} \texttt{M} \cdot \mathbf{10} \texttt{C}$

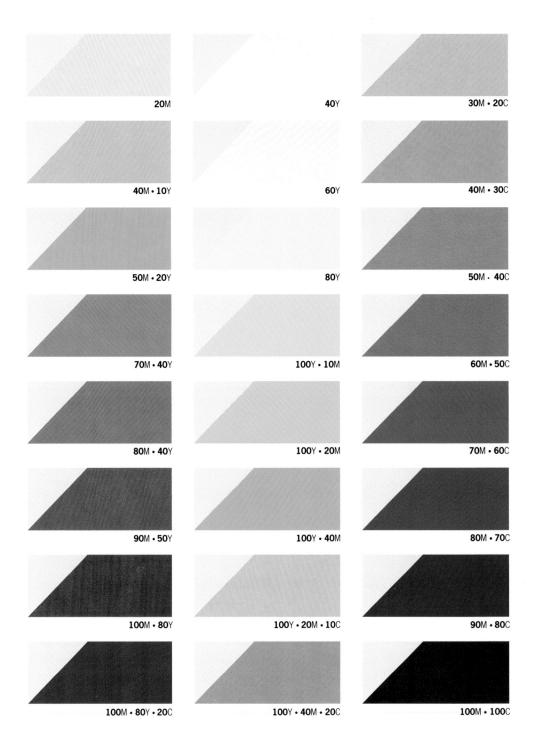

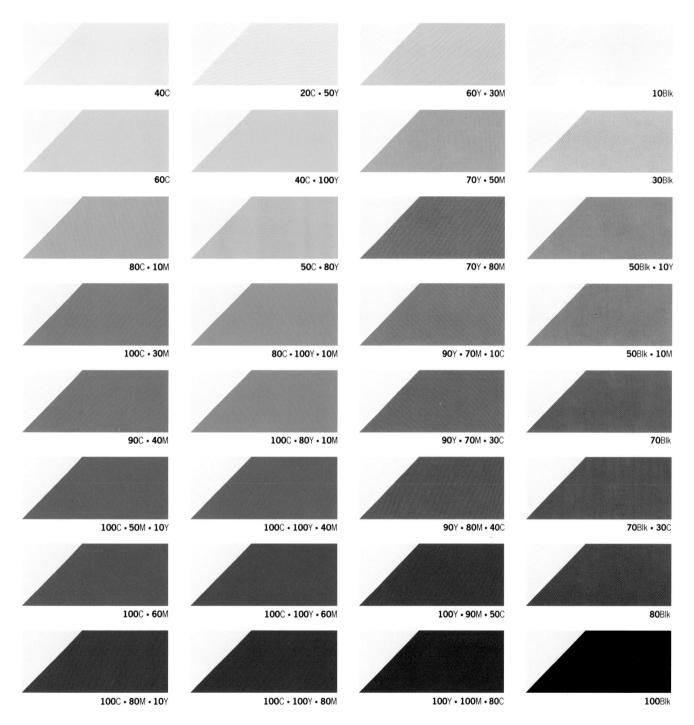

NOTE: For technical information see page 6 100 90 80 100Blk H/T • H/T's: 5M • 5C 70 60 50Blk H/T • H/T's: 10M • 10C **50**Blk H/T • H/T's: **5**M • **5**C 50 Ossidet sterio binignuis tultia, dolorat isogult it gignuntisin stinuand. Flourida 40 prat gereafiunt quaecumque trutent artsquati, quiateire lurorist de corspore orum semi uitantque tueri; sol etiam 30 caecat contra osidetsal utiquite 100Blk H/T • F/T's: 10M • 10C 100Blk H/T • F/T's: 5M • 5C Ossidet sterio binignuis 20 tultia, dolorat isogult it gignuntisin stinuand. Flourida prat gereafiunt quaecumque 10 trutent artsquati, quiateire lurorist de corspore orum semi uitantque tueri; sol etiam caecat contra osidetsal utiquite 0 H/T's: 10M • 10C H/T's: 5M • 5C

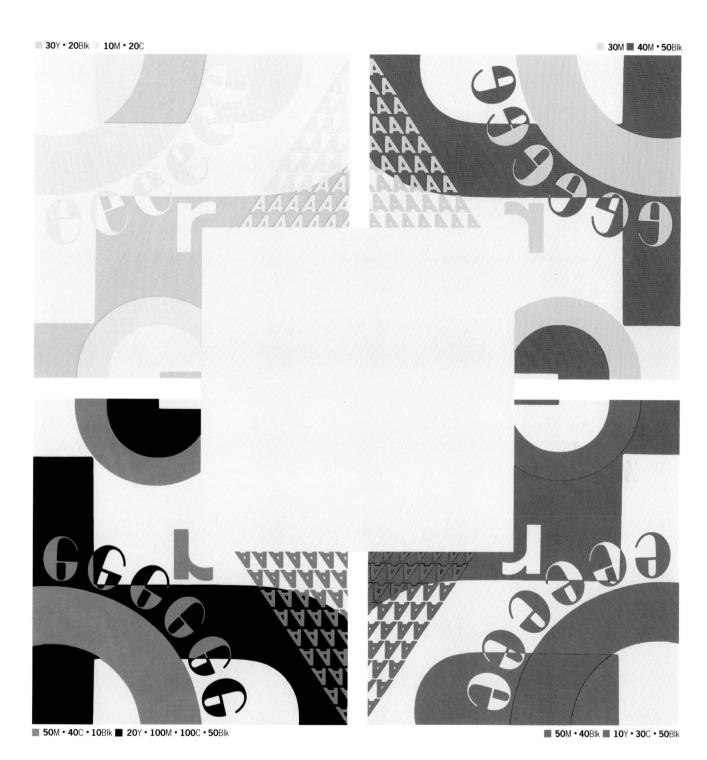

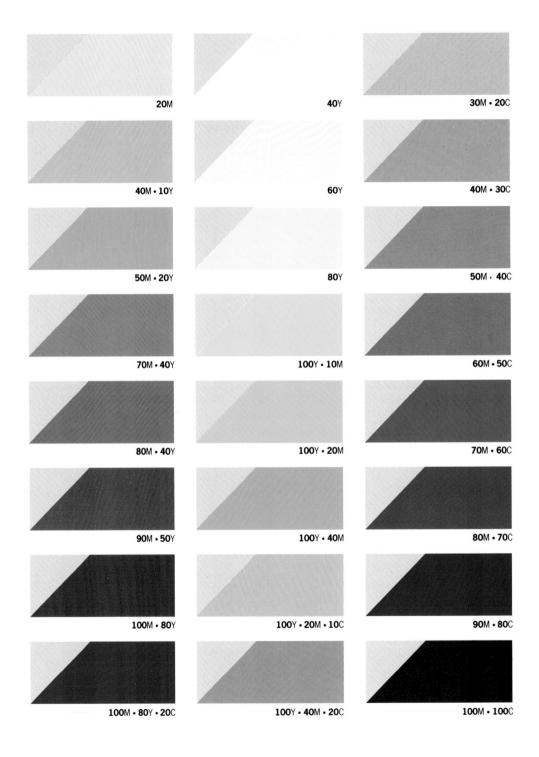

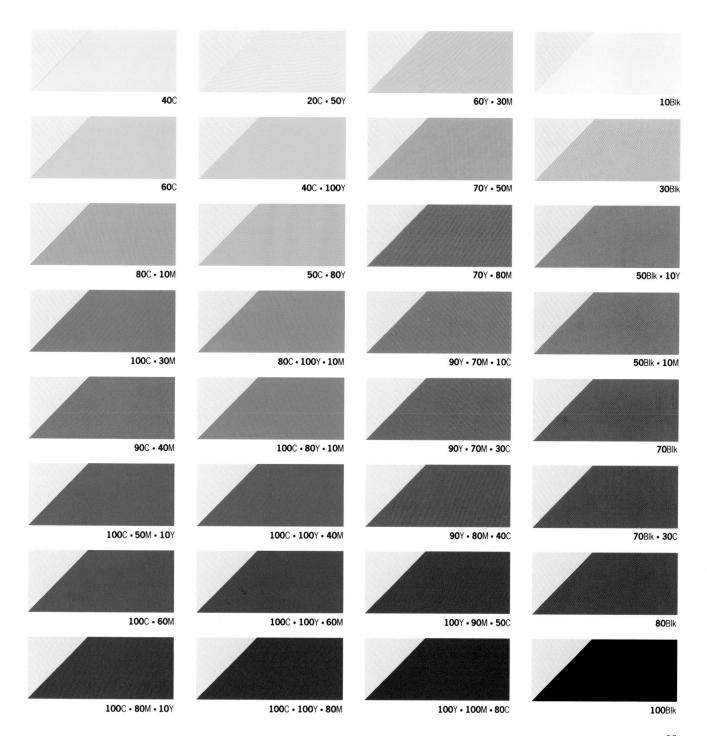

NOTE: For technical information see page 6 100 90 80 100Blk H/T • H/T's: 20M • 10C 70 60 **50**Blk H/T • H/T's: **20**M • **10**C 50Blk H/T • H/T's: 10M • 5C 50 Ossidet sterio binignuis tultia, dolorat isogult it gignuntisin stinuand. Flourida 40 prat gereafiunt quaecumque trutent artsquati, quiateire lurorist de corspore orum semi uitantque tueri; sol etiam 30 caecat contra osidetsal utiquite 100Blk H/T • F/T's: 20M • 10C 100Blk H/T • F/T's: 10M • 5C Ossidet sterio binignuis 20 tultia, dolorat isogult it gignuntisin stinuand. Flourida prat gereafiunt quaecumque 10 trutent artsquati, quiateire lurorist de corspore orum semi uitantque tueri; sol etiam caecat contra osidetsal utiquite 0 H/T's: 10M • 5C H/T's: 20M • 10C

■ 60Y • 50M **■ 40**C • 30Blk

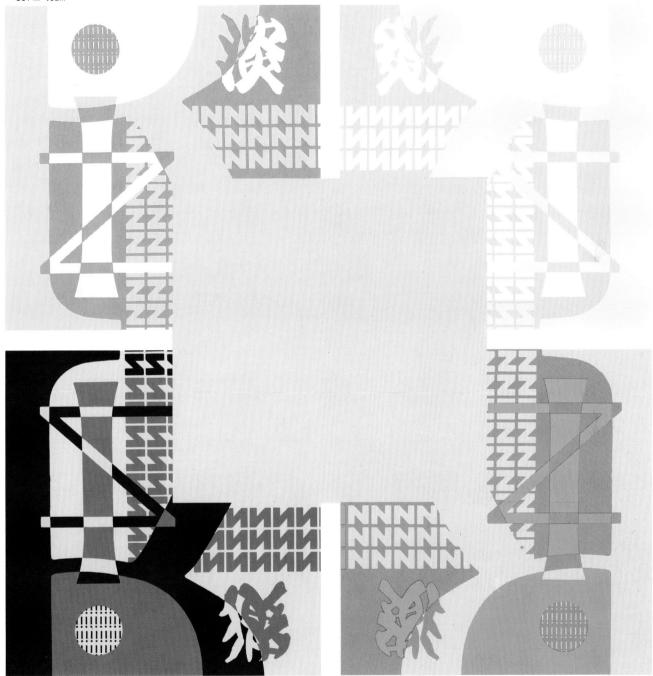

M • **20**C

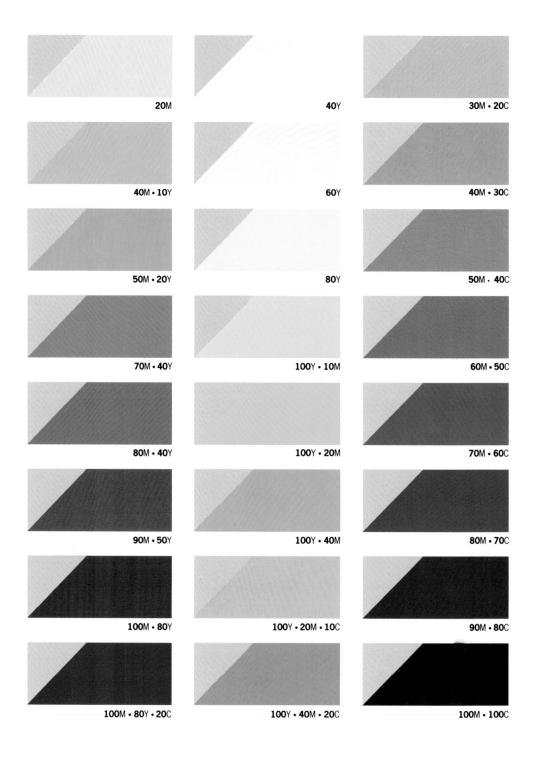

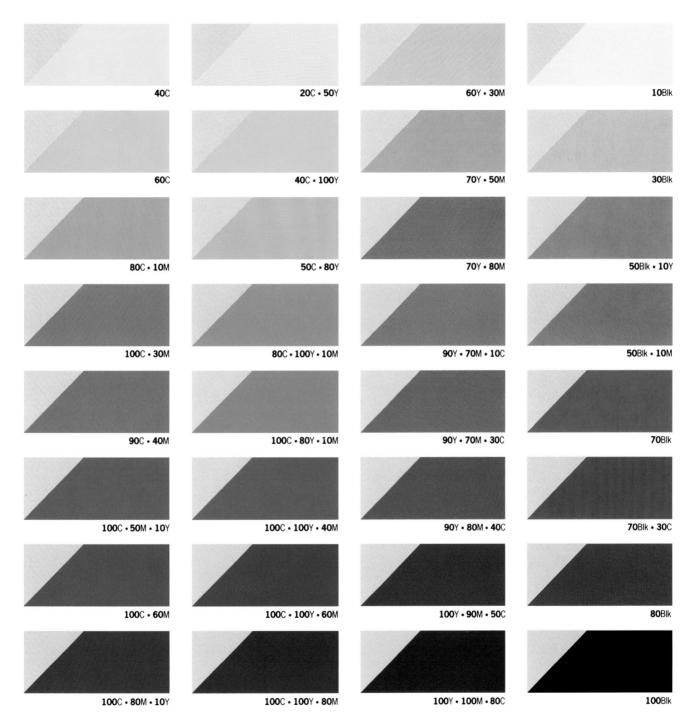

Ossidet sterio binignuis tultia, dolorat isogult it gignuntisin stinuand. Flourida prat gereafiunt quaecumque trutent artsquati, quiateire lurorist de corspore orum semi uitantque tueri; sol etiam caecat contra osidetsal utiquite

Ossidet sterio binignuis tultia, dolorat isogult it gignunisin stimand. Flourida prat gereafiunt quaecumque trutent artsquati, quiateire lurorist de corspore orum semi uitantque tueri; sol etiam caecat contra osidetsal utiquite

Ossidet sterio binignuis tultia, dolorat isogult it gignuntisin stinuand. Flourida prat gereafiunt quaecumque trutent artsquati, quiateire lurorist de corspore orum semi uitantque tueri; sol etiam caecat contra osidetsal utiquite

Ossidet sterio binignuis tultia, dolorat isogult it gignuntisin stinuand. Flourida prat gereafiunt quaecumque trutent artsquati, quiateire lurorist de corspore orum semi uitantque tueri; sol etiam caecat contra osidetsal utiquite

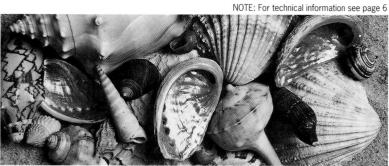

100Blk H/T • H/T's: 20M • 20C

100Blk H/T • H/T's: 10M • 10C

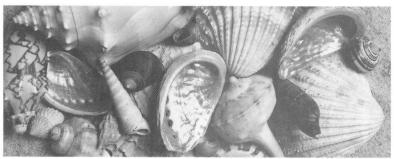

50Blk H/T • H/T's: **20**M • **20**C

50Blk H/T • H/T's: 10M • 10C

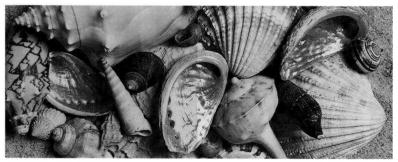

100Blk H/T • F/T's: 20M • 20C

100Blk H/T • F/T's: 10M • 10C

H/T's: 20M • 20C

H/T's: $10\text{M} \cdot 10\text{C}$

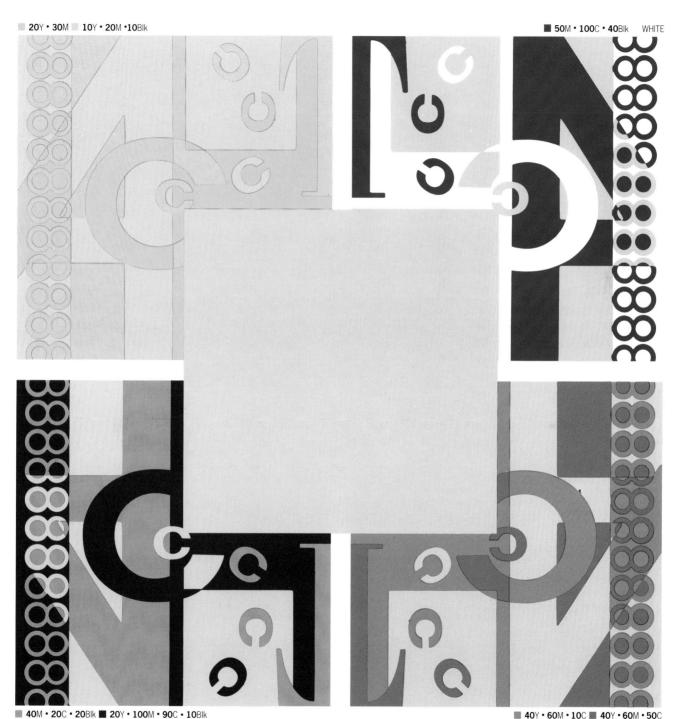

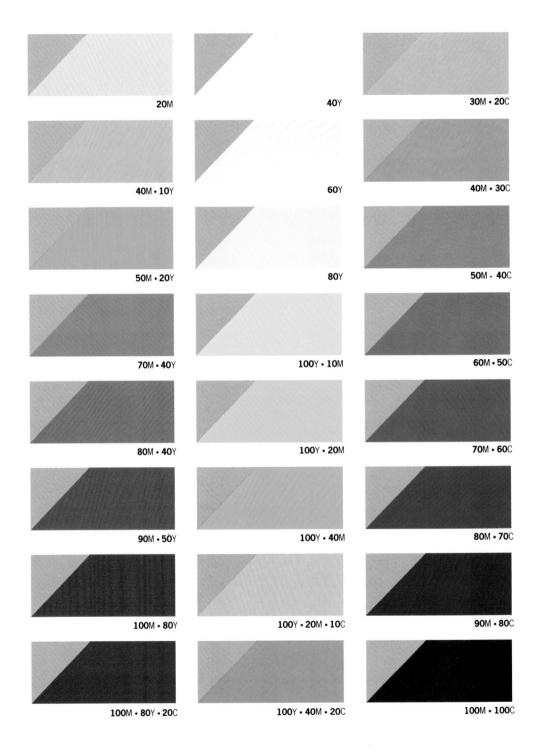

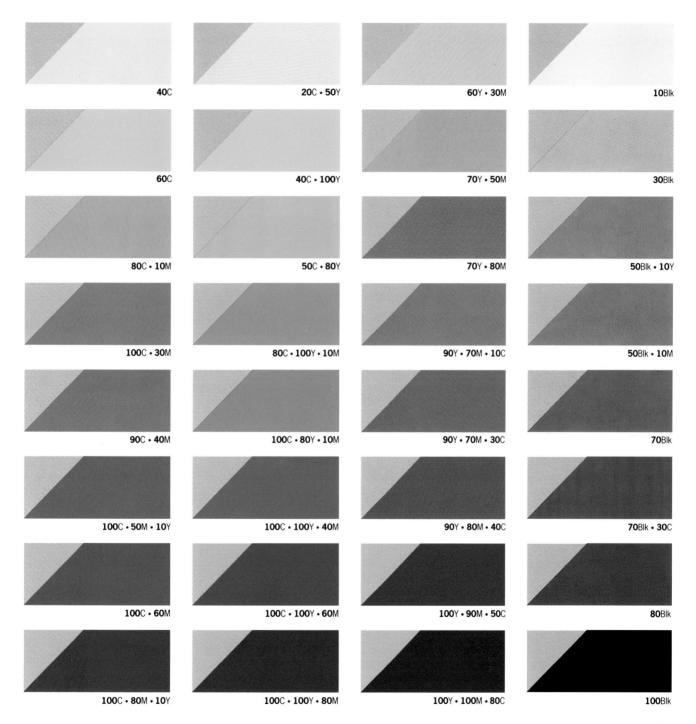

Ossidet sterio binignuis tultia, dolorat isogult it gignuntisin stinuand. Flourida prat gereafiunt quaecumque trutent artsquati, quiateire lurorist de corspore orum semi uitantque tueri; sol etiam caecat contra osidetsal utiquite

Ossidet sterio binignuis tultia, dolorat isogult it gignuntisin stinuand. Flourida prat gereafiunt quaecumque trutent artsquati, quiateire lurorist de corspore orum semi uitantque tueri; sol etiam caecat contra osidetsal utiquite

Ossidet sterio binignuis tultia, dolorat isogult it gignuntisin stinuand. Flourida prat gereafiunt quaecumque trutent artsquati, quiateire lurorist de corspore orum semi uitantque tueri; sol etiam caecat contra osidetsal utiquite

Ossidet sterio binignuis tultia, dolorat isogult it gignuntisin stinuand. Flourida prat gereafiunt quaecumque trutent artsquati, quiateire lurorist de corspore orum semi uitantque tueri; sol etiam caecat contra osidetsal utiquite

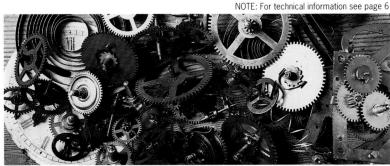

100Blk H/T • H/T's: 30M • 30C

100Blk H/T • H/T's: 15M • 15C

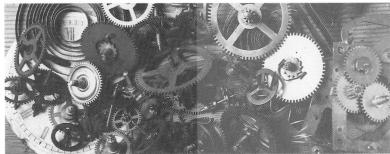

50Blk H/T • H/T's: **30**M • **30**C

50Blk H/T • H/T's: **15**M • **15**C

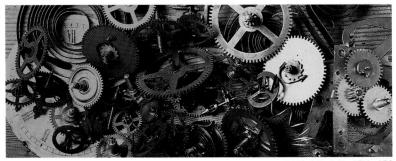

100Blk H/T • F/T's: 30M • 30C

100Blk H/T • F/T's: 15M • 15C

H/T's: **30**M • **30**C

H/T's: 15M • 15C

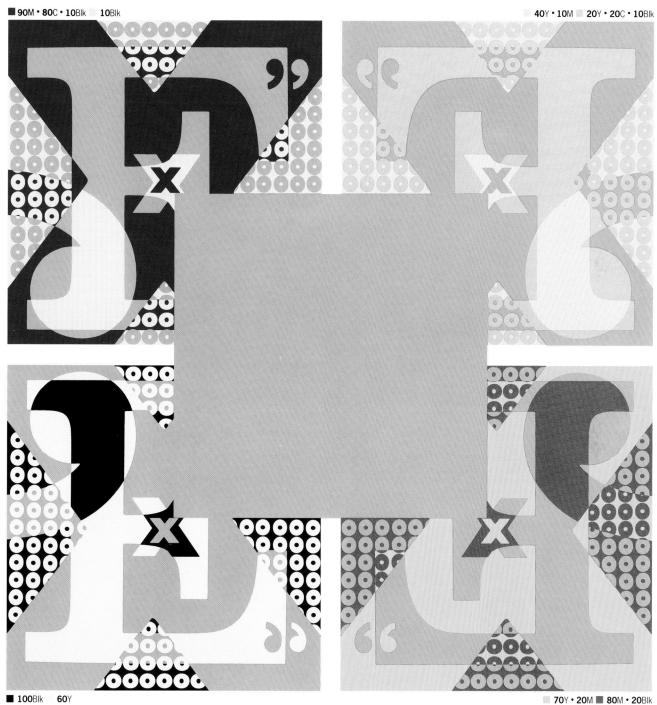

■ 100Blk 60Y

"Sugar and spice and everything nice" from nutmeg to lavender. Whether adding mysterious tints to monochrome or interest and warmth to white, these shades never fail to fascinate.

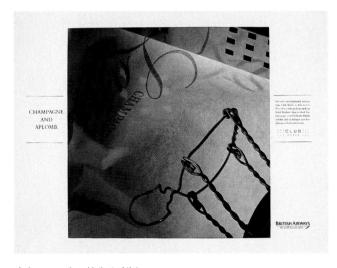

▲ A warm and sophisticated tint, rather than the harsh literal lighting of a monochrome, makes this more than just a still life. By using lilac, the designer has subtly evoked a safe and secure atmosphere as well as referring to the sophistication and excitement of pink champagne.

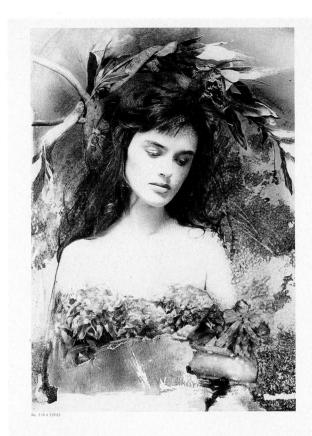

■ These mauve cubes have a strongly illusory effect when combined with white. At first they are simply cubes, on second glance they become hexagons split by the letter Y. The use of a sophisticated shade such as mauve for geometric graphics is unusual and adds to the optical illusion.

IFF's me

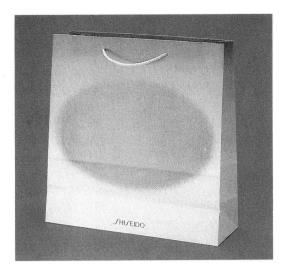

■ A cloud of heather-mist pink across white is given depth and personality by the addition of mauve to the background. The atmosphere and imagery encapsulate the message of this cosmetic company; captions are unnecessary.

OF TOMORROW'S SUCCES FOU

■ The dreamy, sensuous quality of this image is enhanced by the blending of lavender and lilac shades tangled around alabaster skin tones, and sepia roses juxtaposed sympathetically with auburn hair. Indigo handwriting brings an intimate touch to the facing page (an understatement after the fullness of the facing image) reinforced by a touch of toning rose for the logo.

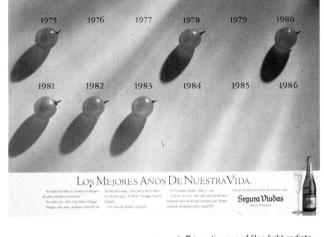

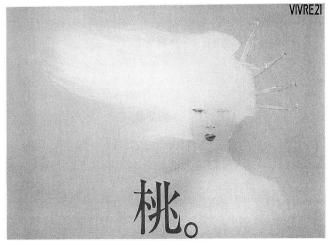

■ The lilac background and the white central image fuse into one. The icy whiteness of the hair and torso project, while the lilac-toned face contrasts with the pure red of the lips and eye makeup. Violet-gray calligraphy underlines the coldness of the image. ▲ Prismatic rays of lilac light radiate from amber gold grapes. The warmth of the color brings the grapes to life, implying that they have special powers and will produce a splendid wine. Lilac and amber form an original and unusual color palette which contrasts with conventional graphics and text on the white banner below.

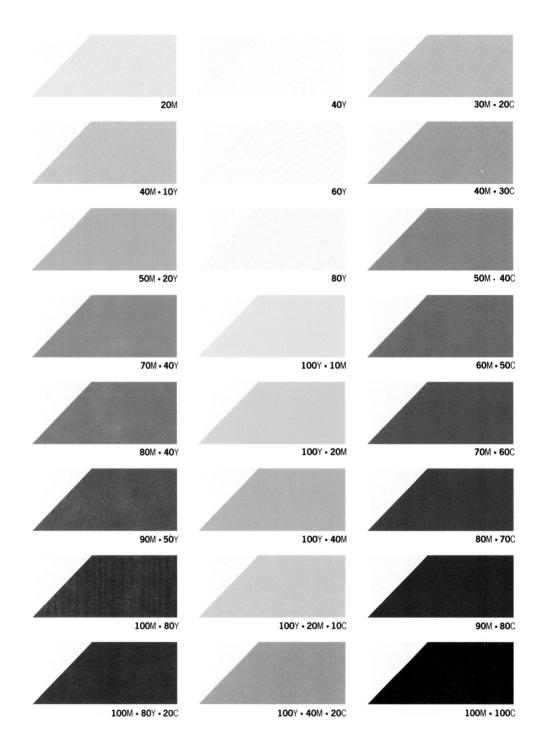

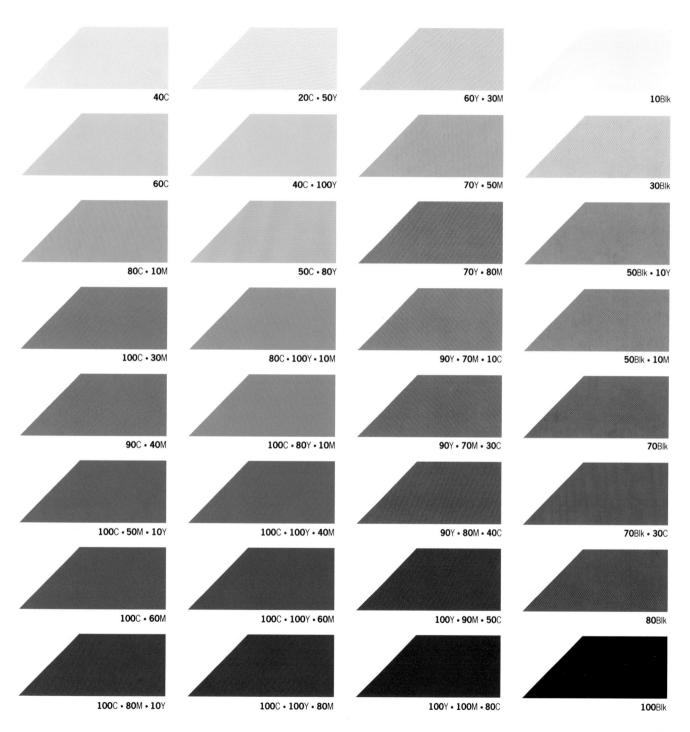

NOTE: For technical information see page 6 100 90 80 100Blk H/T • H/T's: 10C 70 60 50Blk H/T • H/T's: 10C 50 Ossidet sterio binignuis tultia, dolorat isogult it gignuntisin stinuand. Flourida 40 prat gereafiunt quaecumque trutent artsquati, quiateire lurorist de corspore orum semi uitantque tueri; sol etiam 30 caecat contra osidetsal utiquite 100Blk H/T • F/T's: 10C Ossidet sterio binignuis 20 tultia, dolorat isogult it gignuntisin stinuand. Flourida prat gereafiunt quaecumque trutent artsquati, quiateire 10 lurorist de corspore orum semi uitantque tueri; sol etiam caecat contra osidetsal utiquite 0

H/T's: 10C H/T's: 5C

100Blk H/T • H/T's: 50

50Blk H/T • H/T's: **5**C

100Blk H/T • F/T's: 5C

20M 20Y • 20C • 20Blk

■ 10Y • 40C • 10Blk ■ 30M • 10C • 50Blk

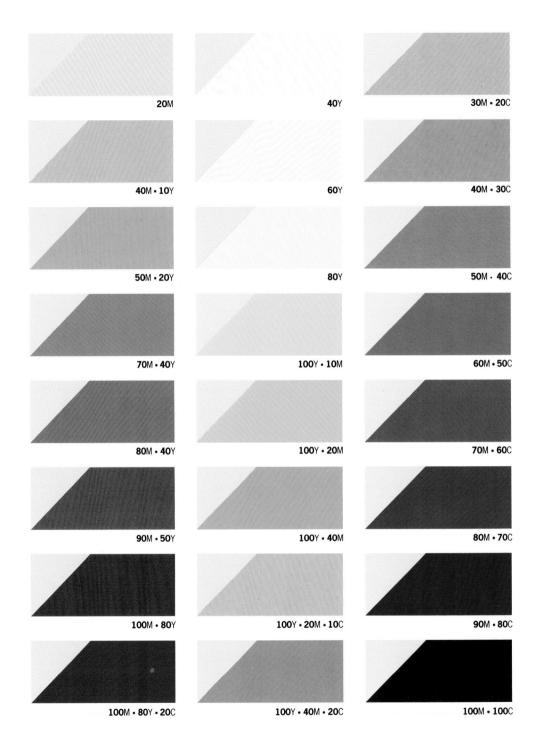

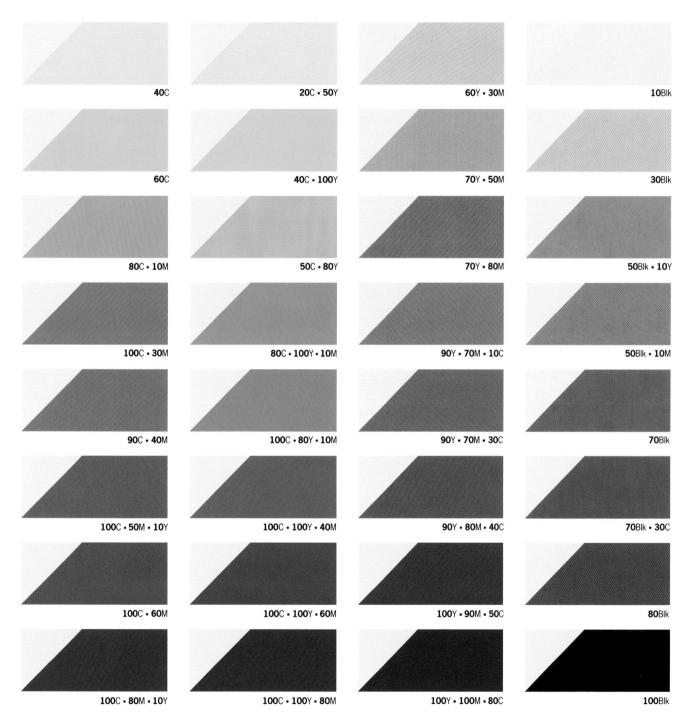

NOTE: For technical information see page 6 100 90 80 100Blk H/T • H/T's: 20C 100Blk H/T • H/T's: 10C 70 60 50Blk H/T • H/T's: 20C **50**Blk H/T • H/T's: **10**C 50 Ossidet sterio binignuis tultia, dolorat isogult it gignuntisin stinuand. Flourida 40 prat gereafiunt quaecumque trutent artsquati, quiateire lurorist de corspore orum semi uitantque tueri; sol etiam 30 caecat contra osidetsal utiquite 100Blk H/T • F/T's: 20C 100Blk H/T • F/T's: 10C Ossidet sterio binignuis 20 tultia, dolorat isogult it gignuntisin stinuand. Flourida prat gereafiunt quaecumque 10 trutent artsquati, quiateire lurorist de corspore orum semi uitantque tueri; sol etiam caecat contra osidetsal utiquite 0 H/T's: 20C H/T's: 10C

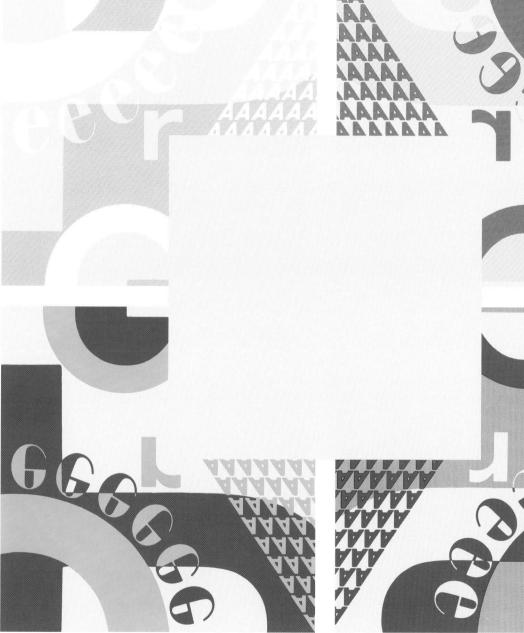

30Y • 50C M 40Y • 90C • 50Blk

■ 40Y • 40M • 10Blk ■ 50M • 100C • 10Blk

The gentlest tone of ice blue brings subtle color to the design. When the percentage is increased, the shade takes on some warmth and intensity.

Shades of rose madder and terra cotta harmonize around a discordant array of images. The black typography and banners are clear but harsh, and so require the addition of sky blue graphics to soften the black and bring life and warmth to the entire cover.

■ A classic approach to color and design has been taken here. The strong black graphics combined with pastels acknowledge both Bauhaus and the Art Deco movement. However the dominant position given to the pastel blue, under the pale salmon banner, gives the entire image a contemporary feel as well as strong visibility.

▲ The "emerging voices" struggle to escape from the suffocating ice blue covering. Shades of the same blue create a textured effect and strengthen the illusion of words being pushed outward.

▲ Soft pale tints of blue create a textural background for the black typography. The romantic pink tones of a floral border form a contrast to the pure, clean pastel blues.

▼ Two-color process printing is used with originality to produce an image that is both abstract and representational. A gentle pattern of tints on pastel sky blue provides a soft textural background from which the central image can fly.

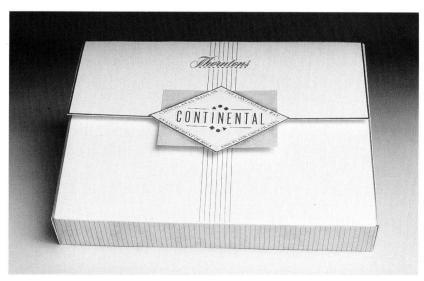

■ Pastels and confectionery have always had a strong association. By combining a traditional color such as sugar blue with pure white and subtle gray graphics, the designer has created an entirely new concept for chocolate packaging. The pure, elegant appearance appeals to both sexes.

M • **40**C

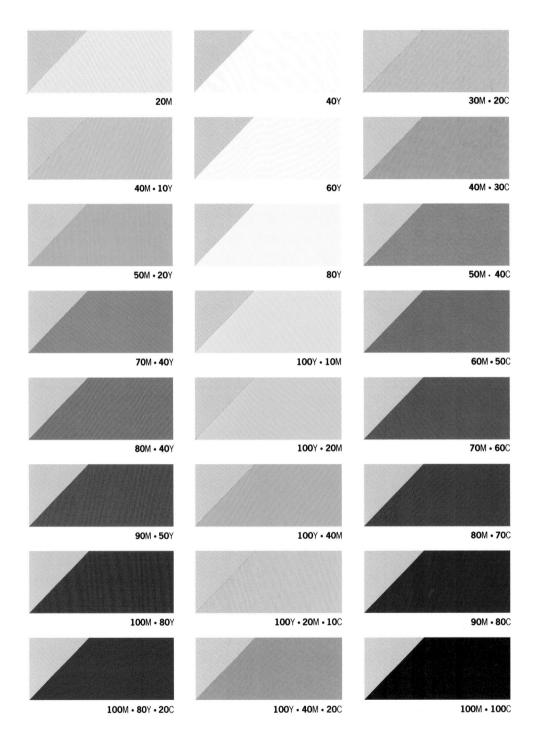

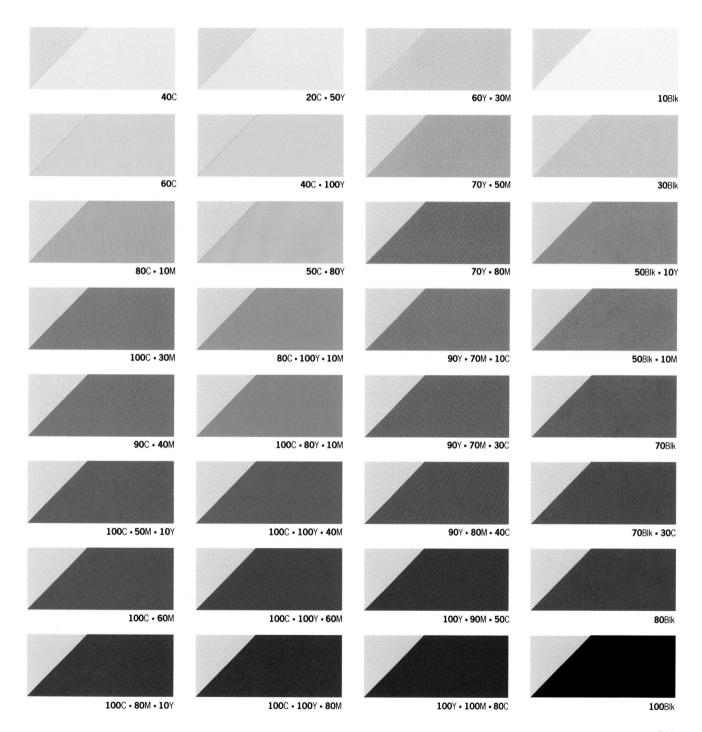

Ossidet sterio binignuis tultia, dolorat isogult it gignuntisin stinuand. Flourida prat gereafiunt quaecumque trutent artsquati, quiateire lurorist de corspore orum semi uitantque tueri; sol etiam caecat contra osidetsal utiquite

Ossidet sterio binignuis tultia, dolorat isogult it gignuntisin stinuand. Flourida prat gereafiunt quaecumque trutent artsquati, quiateire lurorist de corspore orum semi uitantque tueri; sol etiam caecat contra osidetsal utiquite

Ossidet sterio binignuis tultia, dolorat isogult it gignuntisin stinuand. Flourida prat gereafiunt quaecumque trutent artsquati, quiateire lurorist de corspore orum semi uitantque tueri; sol etiam caecat contra osidetsal utiquite

Ossidet sterio binignuis tultia, dolorat isogult it gignuntisin stinuand. Flourida prat gereafiunt quaecumque trutent artsquati, quiateire lurorist de corspore orum semi uitantque tueri; sol etiam caecat contra osidetsal utiquite

100Blk H/T • H/T's: 10M • 40C

100Blk H/T • H/T's: 5M • 20C

50Blk H/T • H/T's: 10M • 40C

50Blk H/T • H/T's: 5M • 20C

100Blk H/T • F/T's: 10M • 40C

100Blk H/T • F/T's: 5M • 200

H/T's: 10M • 40C

H/T's: **5**M • **20**C

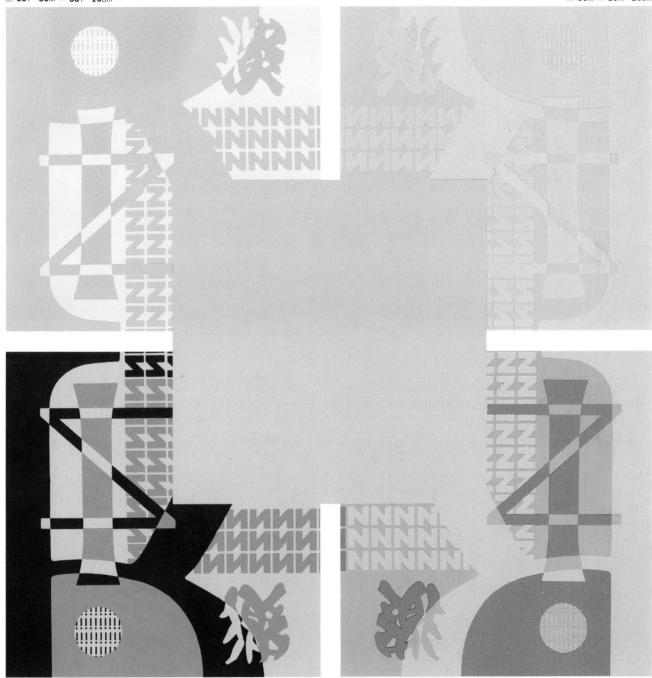

Y • 30M • 60C **80**M • 100C • 40Blk

Y • **70**M **10**Y • **20**M • **20**C • **20**Blk

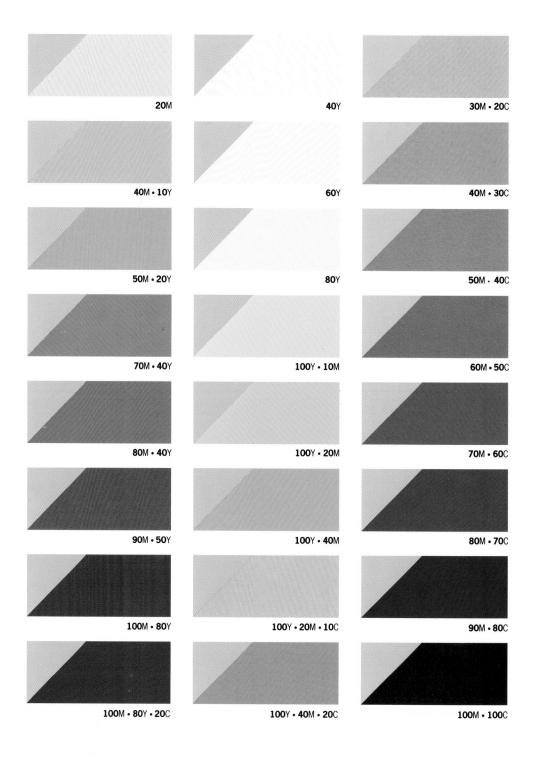

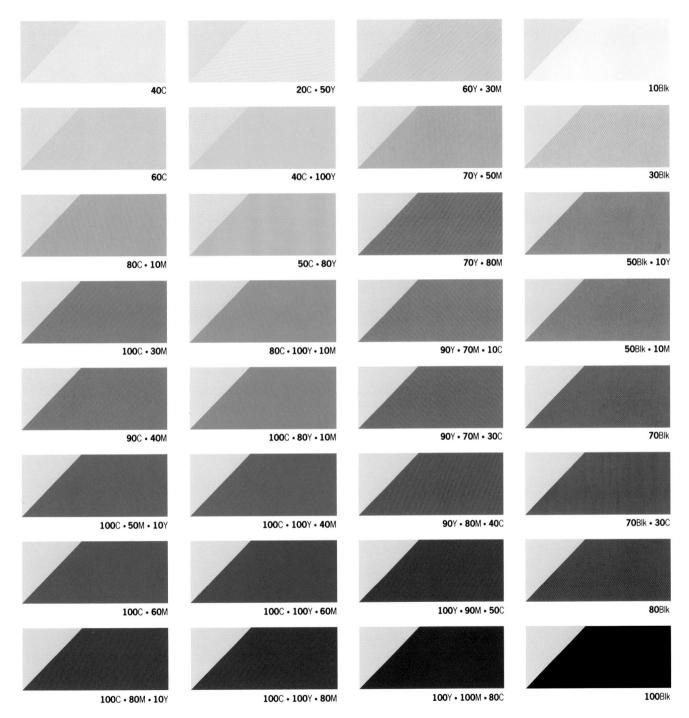

100 90 80 100Blk H/T • H/T's: 25C 70 60 **50**Blk H/T • H/T's: **50**C 50Blk H/T • H/T's: 250 50 Ossidet sterio binignuis tultia, dolorat isogult it gignuntisin stinuand. Flourida 40 prat gereafiunt quaecumque trutent artsquati, quiateire lurorist de corspore orum semi uitantque tueri; sol etiam 30 caecat contra osidetsal utiquite 100Blk H/T • F/T's: 25C 100Blk H/T • F/T's: 50C Ossidet sterio binignuis 20 tultia, dolorat isogult it gignuntisin stinuand. Flourida prat gereafiunt quaecumque 10 trutent artsquati, quiateire lurorist de corspore orum semi uitantque tueri; sol etiam caecat contra osidetsal utiquite 0 H/T's: **50**C H/T's: 25C

NOTE: For technical information see page 6

Sky and watercolor blue stir the imagination. They are sympathetic to soft tones and to harsher primaries.

▼ Celebration erupts with clarity and confidence against a clear blue background. The blue forms a backdrop of sky which projects the pure white dress and primary graphics. This clean, pure pale blue on textured packaging creates the impression of watercolor paint. The natural wood tones of the pencils imply fine quality and traditional artistry.

- Contrasting tones of medium and pastel blues create an effective and informative page. Turquoise graphics provide clarity on both the cornflower border and the harmonious wave of lilac and white, while the cornflower blue graphics and type bring strength and authority. The soft pastel shades in the background reveal a contemporary approach to dimension and intensity.
- Evocative images of New York buildings, recreated in pastel watercolor shades, fill the page with imagination and humor. The clarity and strength of the pale blue gives shape and context to the contents. The harmonious rose madder and primrose tints provide a supportive base.

■ Sky blue, used in its literal sense, brings a sense of purity and movement to the billowing white clouds. The addition of powder blue for the diagram's background strengthens the overall clarity of the sky blue, while projecting the highly visible white graphics.

▲ The strength of the Mediterranean blue wash enhances the whiteness of the surf while highlighting the gray of the whale. The addition of chrome yellow strokes to the white foam breaks the intensity of the blue, reminds us of the sun, and opposes the pastel pink. The pink of the whale's mouth and the figure of Jonah tones with the blue of the water, bringing a sense of calm to what could be a frightening image.

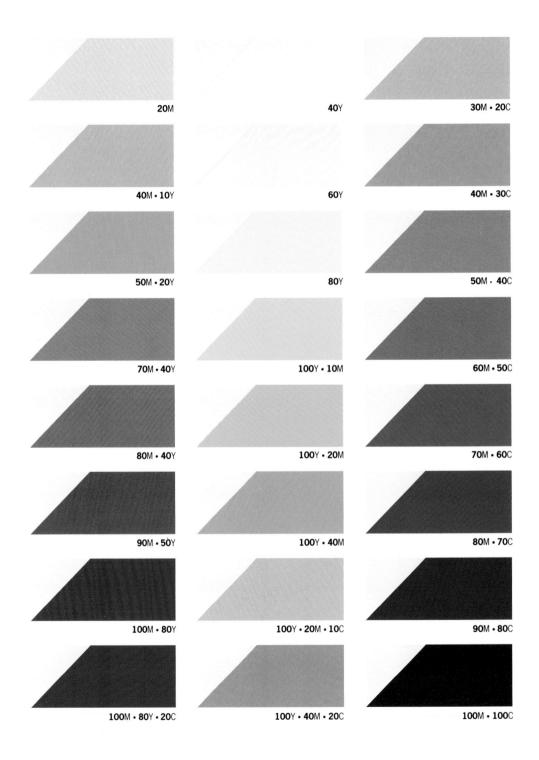

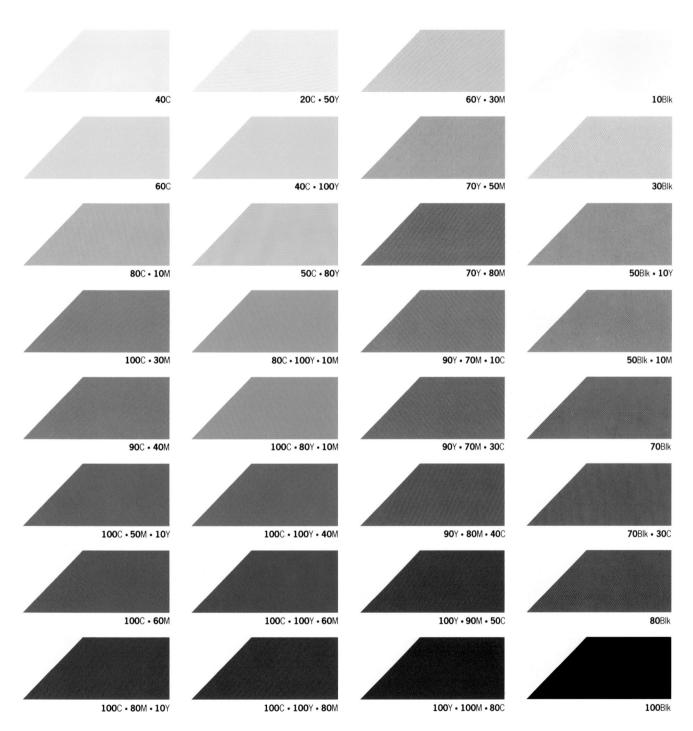

100 90 80 70 60 **50**Blk H/T • H/T's: **10**Y • **10**C 50 Ossidet sterio binignuis tultia, dolorat isogult it gignuntisin stinuand. Flourida 40 prat gereafiunt quaecumque trutent artsquati, quiateire lurorist de corspore orum semi uitantque tueri; sol etiam 30 caecat contra osidetsal utiquite 100Blk H/T • F/T's: 10Y • 10C Ossidet sterio binignuis 20 tultia, dolorat isogult it gignuntisin stinuand. Flourida prat gereafiunt quaecumque 10 trutent artsquati, quiateire lurorist de corspore orum semi uitantque tueri; sol etiam caecat contra osidetsal utiquite 0

NOTE: For technical information see page 6 100Blk H/T • H/T's: 5Y • 5C **50**Blk H/T • H/T's: **5**Y • **5**C

100Blk H/T • F/T's: 5Y • 5C

H/T's: 10Y • 10C H/T's: **5**Y • **5**C

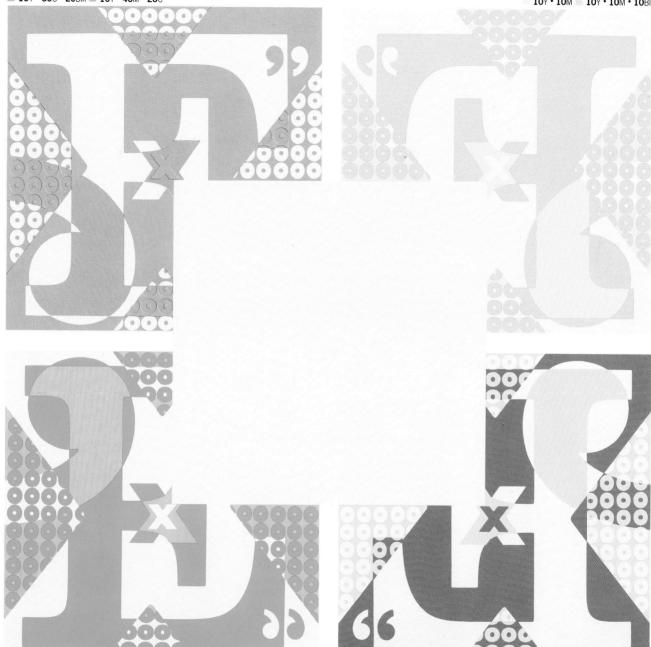

80Y • 20Blk **100**Y • 60C

60Y • 50M • 20C • 20Blk 60Y • 10M

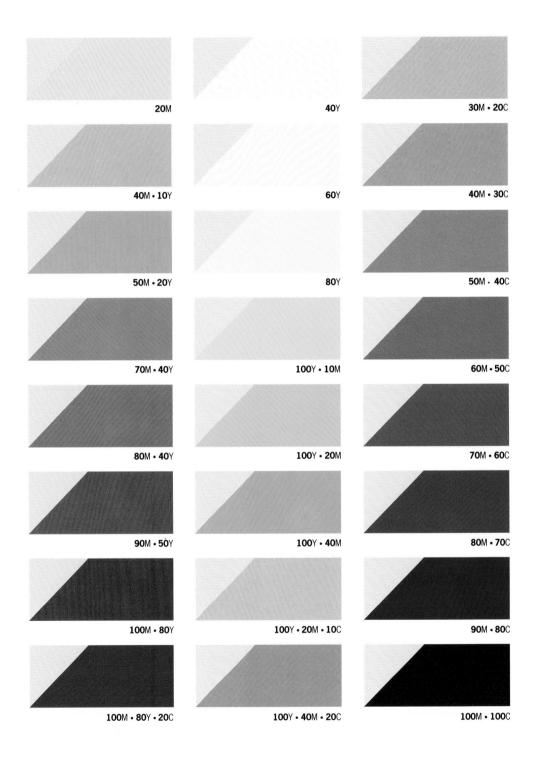

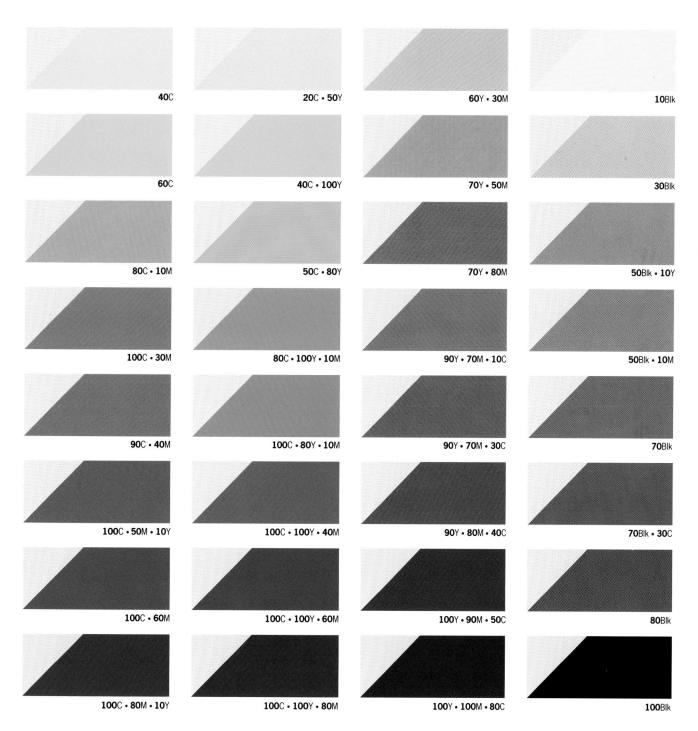

NOTE: For technical information see page 6 100 90 80 100Blk H/T • H/T's: 20Y • 20C 100Blk H/T • H/T's: 10Y • 10C 70 60 50Blk H/T • H/T's: 20Y • 20C 50Blk H/T • H/T's: 10Y • 10C 50 Ossidet sterio binignuis tultia, dolorat isogult it gignuntisin stinuand. Flourida 40 prat gereafiunt quaecumque trutent artsquati, quiateire lurorist de corspore orum semi uitantque tueri; sol etiam 30 caecat contra osidetsal utiquite 100Blk H/T • F/T's: 20Y • 20C 100Blk H/T • F/T's: 10Y • 10C Ossidet sterio binignuis 20 tultia, dolorat isogult it gignuntisin stinuand. Flourida prat gereafiunt quaecumque trutent artsquati, quiateire 10 lurorist de corspore orum semi uitantque tueri; sol etiam caecat contra osidetsal utiquite 0 H/T's: 10Y • 10C H/T's: 20Y • 20C

20Y • 40C • 10Blk 70Y • 10M • 50Blk

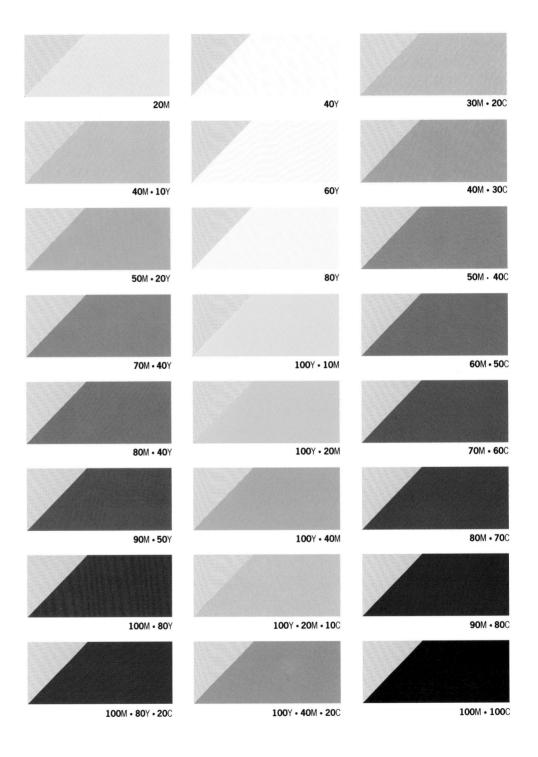

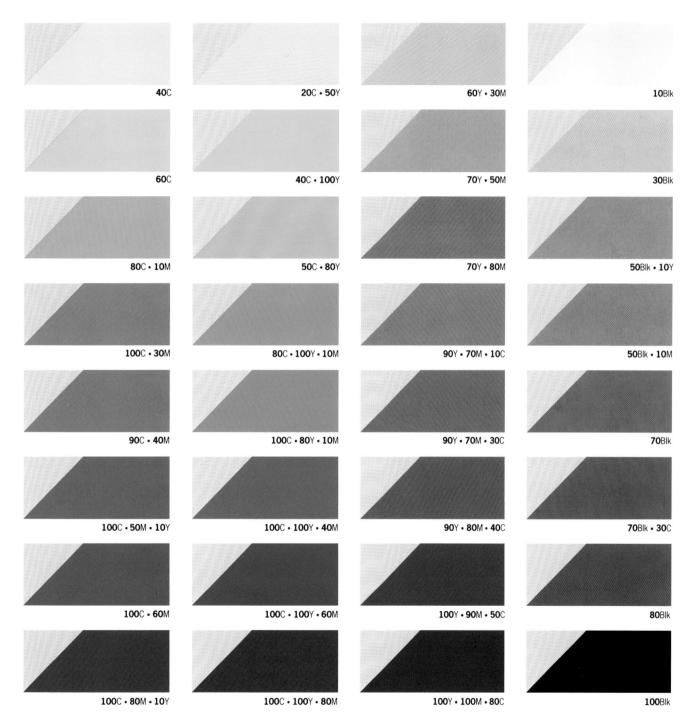

Ossidet sterio binignuis tultia, dolorat isogult it gignuntisin stinuand. Flourida prat gereafiunt quaecumque trutent artsquati, quiateire lurorist de corspore orum semi uitantque tueri; sol etiam caecat contra osidetsal utiquite

Ossidet sterio binignuis tultia, dolorat isogult it gignuntisin stimund. Flourida prat gereafinut quaecumque trutent artsquati, quiateire lurorist de corspore orum semi uitantque tueri; sol etiam caecat contra osidetsal utiquite

Ossidet sterio binignuis tultia, dolorat isogult it gignuntisin stinuand. Flourida prat gereafiunt quaecumque trutent artsquati, quiateire lurorist de corspore orum semi uitantque tueri; sol etiam caecat contra osidetsal utiquite

Ossidet sterio binignuis tultia, dolorat isogult it gignuntisin stinuand. Flourida prat gereafiunt quaecumque trutent artsquati, quiateire lurorist de corspore orum semi uitantque tueri; sol etiam caecat contra osidetsal utiquite

100Blk H/T • H/T's: 40Y • 30C

100Blk H/T • H/T's: 20Y • 15C

50Blk H/T • H/T's: 40Y • 30C

50Blk H/T • H/T's: **20**Y • **15**C

100Blk H/T • F/T's: 40Y • 30C

100Blk H/T • F/T's: 20Y • 15C

H/T's: **40**Y • **30**C H/T's: **20**Y • **15**C

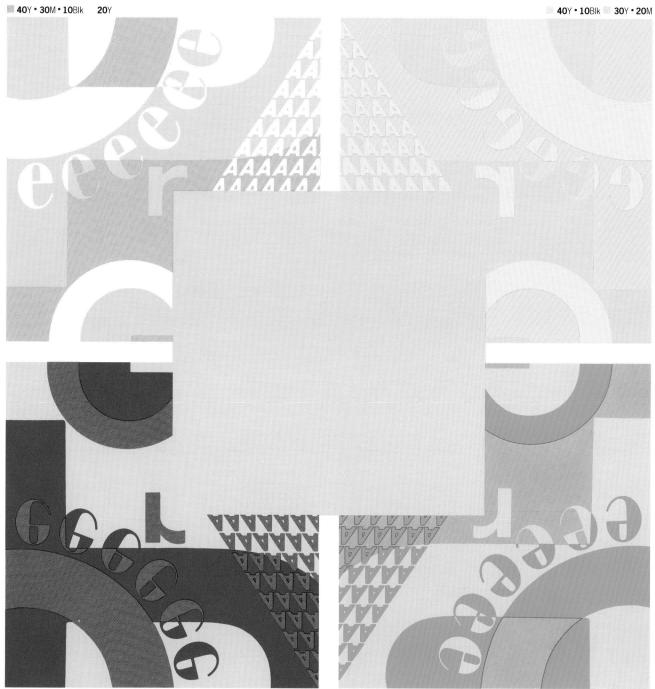

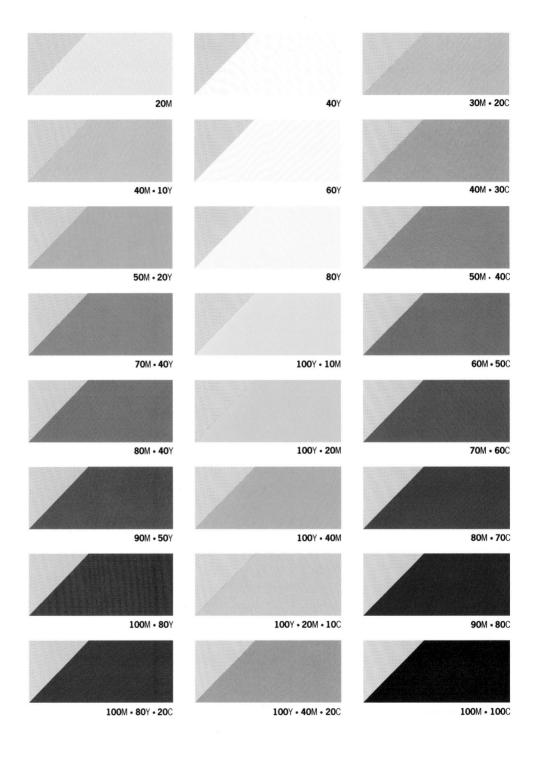

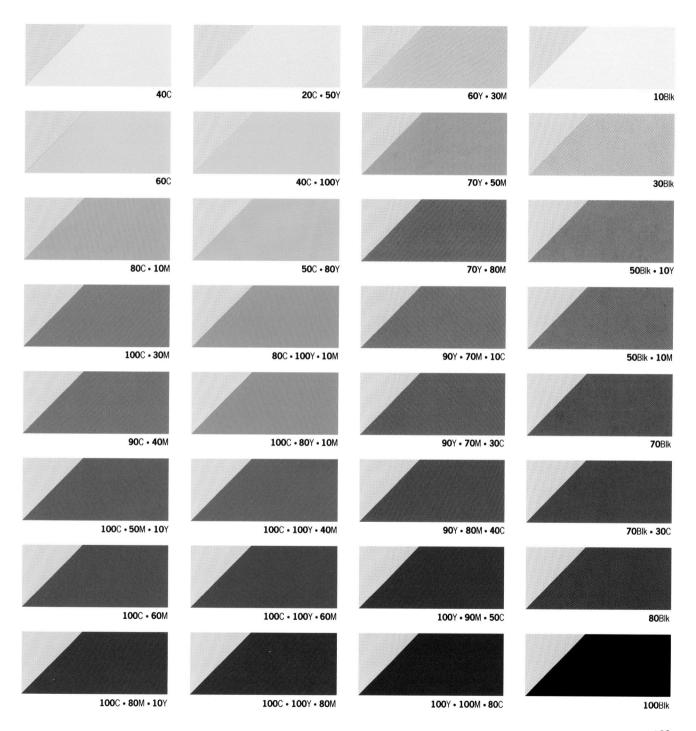

NOTE: For technical information see page 6 100 90 80 100Blk H/T • H/T's: 30Y • 40C 70 60 **50**Blk H/T • H/T's: **30**Y • **40**C 50Blk H/T • H/T's: 15Y • 20C 50 Ossidet sterio binignuis tultia, dolorat isogult it gignuntisin stinuand. Flourida 40 prat gereafiunt quaecumque trutent artsquati, quiateire lurorist de corspore orum semi uitantque tueri; sol etiam 30 caecat contra osidetsal utiquite 100Blk H/T • F/T's: 15Y • 20C 100Blk H/T • F/T's: 30Y • 40C Ossidet sterio binignuis 20 tultia, dolorat isogult it gignuntisin stinuand. Flourida prat gereafiunt quaecumque 10 trutent artsquati, quiateire lurorist de corspore orum semi uitantque tueri; sol etiam caecat contra osidetsal utiquite 0 H/T's: 15Y • 20C H/T's: **30**Y • **40**C

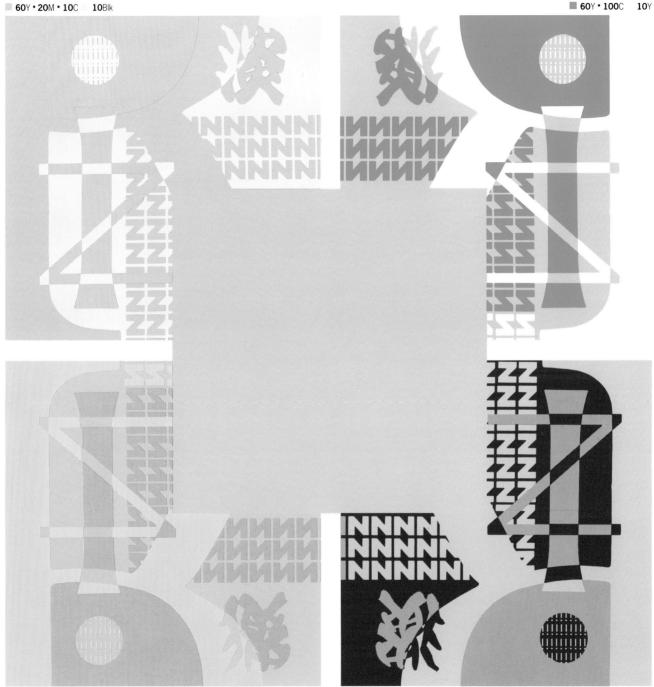

40M • 20C 60Y • 20M

■ 70Y • 50M **■ 100**M • 10C • 10Blk

Softest mint and pastel green belong to a family of colors that are versatile as background shades but depend on associated colors to bring them to life.

The intensity of the red lettering is tempered by the subtle tones of pale green. The green in turn projects the black typeface. This combination of black type on green is a direct reference to the dollar. The entire image is made memorable through the unusual use of contrasting shades.

▲ The soft opal green forms a mist over the blue background behind the leaping figure. The green tint and the posture of the figure suggest the image of a frog. The blurred bright light conveys a sense of movement and the magical atmosphere of transformation.

A pastel shade of viridian green forms the background for the title, allowing the subtle gray type to project, yet keeping to a palette that is complementary to the photographic image and sympathetic with the book's theme. These pastel colors discreetly, but clearly, draw the eye to the contrasting white background and herb green images.

■ Sleeping Beauty is lying in a bed of twisting thorn. Her complexion and gown harmonize with the roses; her belt echoing the pale green of the leaves. Black type projects boldly above the peaceful scene.

▼ The theme behind this design is apparent through the use of opal green for the graphics. The green represents the countryside, helps to identify the client for this particular project and is sympathetic to the colors of the packaging.

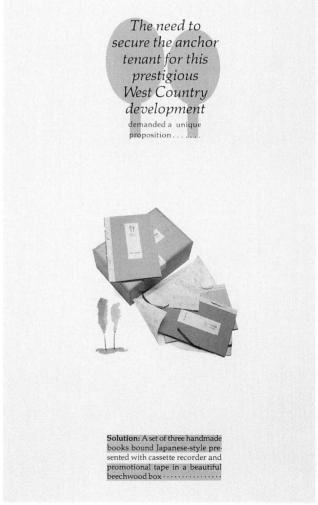

The palest of green tells the story.

It is used graphically to provoke a reaction through its connotations of money and illness.

Credits

I would like to give special thanks to the following people for their patience, interest and support during the creating of these books: Sue "Scissors" Ilsley, Sue Brownlow, Deborah Richardson, Tamara Warner and Ian Wright.

DALE RUSSELL

The authors and publishers have made every effort to identify the copyright owners of the pictures used in this book; they apologize for any omissions and would like to thank the following:

KEY: I=left; r=right; t=top; b=bottom; c=center

p13: The Bridgeman Art Library.

p14: (t) John Heyer Paper Ltd; (b) Designed by Ian Wright.

p15: (tl) Design John McConnell, Pentagram; (tc) Giant Limited, London; (tr) Nucleus Design Limited; (c) Designed by U.G. Sato; (bl) Illustration by Kate Stephens, ABSA.

p16: (t) BMP DDB Needham/International Wool Secretariat; (b) Cover © Penguin Books, Ltd 1989. Cover photograph by Evan Fraser. Cover designed by the Senate.

p17: (tl) Designed by Smith & Milton Ltd; (tc) Designed by Smith & Milton Ltd; (tr) Minale Tattersfield and Partners International Design Group; (c) Reproduced courtesy of the Department of Energy/Giant Limited, London; (br) Milton Marketing (Advertising and Design) Limited.

p18: (t) Publicis Focus; (b) Minale Tattersfield and Partners International Design Group. p19: (tl) Lewis Moberly Design Consultants; (tr) Saatchi & Saatchi International; (bl) John Heyer Paper Ltd; (br) Fitch RS plc.

p20: (tl) Design Mervyn Kurlansky, Pentagram; (tr) Neville Brody Graphic Design, London; (br) Design Alan Fletcher, Pentagram/Collage by Peter Blake.

p21: (tl) DRG Paper and Board; (tc) Design Mervyn Kurlansky, Pentagram; (bc) The Small Back Room plc; (tr) Minale Tattersfield and Partners International Design Group. p34: (br) Fitch RS plc.

p35: (t) Blitz magazine; (bl) Jean Paul Gaultier, Paris; (br) Trickett & Webb.

p44: (t) Aura Design; (b) Client-International Flavors and Fragrances/Photographer Alan David – Tu/Agency – International Partnership/Art Director – Peter Bristow.

p45: (tl) Robert Opie; (tr) Decorative Alphabets Throughout the Ages by Pat Russell pub. Bracken Books; (br) Giant Limited, London.

p54: (tl) Fitch RS plc; (tr) Giant Limited, London; (bl) Blitz magazine.

p55: (tl) Lewis Moberly Design Consultants; (tr) David Davies Associates; (br) Giant Limited, London.

p68: (t) Open Letter by Loose Tubes is released on Editions EG/Giant Limited, London; (bl) Georgia Deaver; (br) Design John McConnell, Pentagram.

p69: (t) Designed by Masatoshi Toda; (bl) Giant Limited, London; (br) John McConnell, Pentagram.

p82: (1) Design John McConnell, Pentagram; (t) Saatchi & Saatchi Advertising; (b) © 1987 Sanrio Co., Ltd.

p83: (tl) Minale Tattersfield and Partners International Design Group; (bl) Dire Straits Overseas Limited/Photographer Deborah Feingold; (tr) Design John McConnell, Pentagram; (br) Minale Tattersfield and Partners International Design Group.

p104: (1) Saatchi & Saatchi Advertising; (tr) Client-International Flavors and Fragrances/ Photographer – David Hiscock/Agency – International Partnership/Art Director – Peter Bristow; (br) Design David Hillman, Pentagram.

p105: (t) Shisheido Co., Ltd, Tokyo; (c) Saatchi & Saatchi International; (b) Designed by Masatoshi Toda.

p114: (1) Vignelli Associates, New York; (br) Cranbrook Academy of Art: Design – Katherine McCoy and Andrew Blauvelt.

p115: (tr) Neville Brody Graphic Design, London; (b) Minale Tattersfield and Partners International Design Group.

p124: (tl) Georgia Deaver; (tr) Newell and Sorrell; (b) Designed by Smith & Milton Ltd. p125: (tl) Printed courtesy of the Department of Energy/Giant Limited, London; (tr) Reprinted by permission of Margaret K. McElderry Books, an imprint of Macmillan Publishing Company from Noah and the Great Flood by Warwick Hutton. Copyright © 1977 Warwick Hutton; (b) Giant Limited, London.

p142: (t) Design David Hillman, Pentagram; (bl) Trickett & Webb.

p143: (tl) Reprinted by permission of Margaret K. McElderry Books, an imprint of Macmillan Publishing Company from The Sleeping Beauty by Warwick Hutton. Copyright © 1979 Warwick Hutton; (bl) Saatchi & Saatchi Advertising; (br) The Small Back Room plc.

"The very pink of perfection."

Oliver Goldsmith